Islam and Motherhood

Studies in Communication, Culture, Race, and Religion

Andre E. Johnson
Series Editor

Vol. 5

JoAnna Boudreaux

Islam and Motherhood

Discourses of Faith and Identity

PETER LANG
New York - Berlin - Bruxelles - Chennai - Lausanne - Oxford

Library of Congress Cataloging-in-Publication Data

Names: Boudreaux, JoAnna, author.
Title: Islam and motherhood: discourses of faith and identity / JoAnna Boudreaux.
Description: 1. | New York: Peter Lang, 2024. | Series: Studies in communication, culture, race, and religion, 2834-7013; vol. 5 | Includes bibliographical references and index.
Identifiers: LCCN 2023040525 (print) | LCCN 2023040526 (ebook) | ISBN 9781433199233 (paperback) | ISBN 9781433199226 (epub) | ISBN 9781433199219 (pdf)
Subjects: LCSH: Motherhood—Religious aspects—Islam. | Mother and child—Religious aspects—Islam. | Parenting—Religious aspects—Islam. | Muslim women—United States. | Mothers—United States.
Classification: LCC BP190.5.M67 B68 2024 (print) | LCC BP190.5.M67 (ebook) | DDC 297.5/77—dc23/eng/20230918
LC record available at https://lccn.loc.gov/2023040525
LC ebook record available at https://lccn.loc.gov/2023040526
DOI 10.3726/b21214

Bibliographic information published by the Deutsche Nationalbibliothek.
The German National Library lists this publication in the German National Bibliography; detailed bibliographic data is available on the Internet at http://dnb.d-nb.de.

Cover design by Peter Lang Group AG

ISSN 2834-7013 (print) ISSN 2771-4543 (online)
ISBN 9781433199233 (paperback)
ISBN 9781433199219 (ebook)
ISBN 9781433199226 (epub)
DOI 10.3726/b21214

© 2024 Peter Lang Group AG, Lausanne
Published by Peter Lang Publishing Inc., New York, USA
info@peterlang.com - www.peterlang.com

All rights reserved.
All parts of this publication are protected by copyright.
Any utilization outside the strict limits of the copyright law, without the permission of the publisher, is forbidden and liable to prosecution.
This applies in particular to reproductions, translations, microfilming, and storage and processing in electronic retrieval systems.

This publication has been peer reviewed.

For Deena and Asiya

بسم الله الرحمن الرحيم

In the Name of God, the Most Gracious, The Most Merciful

CONTENTS

	Acknowledgments	xi
Chapter 1	Introduction	1
Chapter 2	On Motherhood, Mothering, and Islam	17
Chapter 3	Me, Mothers, and This Study	35
Chapter 4	Scripture vs Culture	49
Chapter 5	Mothers' Obligations and Fathers' Roles	57
Chapter 6	Sacrifice and Failure	73
Chapter 7	Final Reflection	81
	Bibliography	97
	Index	105

ACKNOWLEDGMENTS

I am immensely grateful to my husband, Khaled Hamadeh, for making my life exceptionally easier while I worked on this project. I am also grateful for the support and guidance I received from Dr. Katherine Grace Hendrix, Dr. David Gray Matthews, Dr. Michael Vicente Perez, Dr. Andre Johnson, Dr. Craig O. Stewart, and Dr. Antonio de Velasco. Just believing in someone makes all the difference.

· 1 ·
INTRODUCTION

This study is about mothers. For many of us, our first and most enduring relationship is with our mother, and what happens within that relationship can profoundly affect the trajectory of our life. But who is the mother? Blogger Susan Diranian captures the popular conception of the mother when she explains that the mother is she who offers unconditional, selfless love to the child, sacrificing her own wants and needs in the process.[1] The mother is a teacher, nurturer, disciplinarian, and guide. Of course, with such expectations, it is inevitable that some mothers are bound to feel they are always falling short.

When my youngest son was four years old, he once asked: "Why don't you be like other mommies who make cookies and have their hair like this…?" He gestured upwards and made a circular motion with his little hands indicating he preferred my hair in a bun. I was sitting at a table scattered with books, and worksheets. At the time, I was teaching myself to read and write Arabic and I was assiduously writing and rewriting the script in my efforts to become proficient. My hair hung loose and unbrushed. My eyes were rimmed with too much kohl in an unsuccessful attempt to disguise the bleariness.[2] I laughed in surprise and felt suddenly embarrassed- and perhaps a little ashamed. At that moment I realized that my children often saw me in front of books or a

computer screen. I apologized to him and promised to bake him cookies. Later that evening I fulfilled my promise. But the admonishment lingered. I made a mental note to be better.

I married in 1993 when I was 19 years old. My children were born in 1995, 1996, 1997, 2000, and 2001. During those years I was youthful, restless, overwhelmed, and temperamental. And while I never settled into domesticity, I enjoyed spending time with my children. We wrecked our house painting masterpieces, creating craft projects, and doing science experiments. We read books and played games. We planted gardens, caught lightning bugs, and raised caterpillars into butterflies. I washed their faces and hands. I bathed them and put them in their pajamas before bed. But I also studied. I read. I wrote. I played. But I did not cook. My husband was the cook. Now, thirty years into our marriage, with our children grown, he is still the cook. Back then, this was a source of personal tension and shame. After all, as a Muslim family, we seemed to be an outlier. In the families we socialized with, none of the other fathers cooked. Mothers cook. And here was my little son calling me out, confirming the discrepancy. Why couldn't I be like other mothers? The bright-eyed mothers who pin their hair in fashionable updos and cook for their children? The *normal* mothers. The *good* mothers.

There is no doubt that as a young mother, I was insecure. Many of the women around me were amazing cooks and immaculate housekeepers. I was neither. And yet, as I reflect, I recall how other mothers claimed to envy me for the "fun" relationship I had with my children. They sought my advice on parenting strategies and guidance on how to approach their children's different behavioral issues. Some mothers worked, either part-time or full-time, and struggled to "balance" housework and childrearing. Every woman seemed to believe that every other mother was doing it better. We were all insecure. We were all trying to be a "good mother" and failing in one way or another, not realizing that the "good mother" is a myth (Buchanan, 2013; O'Reilly and Porter, 2006; Thurer, 1995; Vandenberg-Daves, 2014). It is a myth that is "culture-bound, historically specific" and hopelessly embedded in the lives of women (Thurer, 1995, p. xxv).

In her landmark book, *Of Woman Born*, Adrienne Rich (1976) distinguished between two meanings of motherhood. Firstly, there is the potential relationship that a woman has with her reproductive capabilities and her children; secondly, there is the social institution that imposes itself upon that relationship. Academic scholars have agreed that "mother" is socially constructed and historically situated under an overarching ideology of "Motherhood"

(Buchanan, 2013; Chodorow, 1979; Ciblis, 2007; Collins, 2008; Kawash, 2011; O'Reilly, 2006; Pappano & Olwan, 2016; Rich, 1986; Ruddick, 1995; Takseva, 2018; Wadud, 2006). Motherhood compels women to have certain behaviors and value systems. Specifically, she should be self-sacrificing and place her own needs after the needs of her children and husband. Consequently, motherhood reinforces, obscures, and sustains a gendered power dynamic. Of course, the nuances and complexities of that dynamic vary depending on cultural memberships, the socio-historic moment, and geographic location. There is too often a stark contrast between the social expectations of mothers to devote themselves entirely and selflessly to their children with the parallel realities of real women's lives and experiences (Ciblis, 2017).

My Trajectory

I grew up observing my own mother, a Thai immigrant, struggle to conform to mainstream expectations of whom a (United States American) mother was supposed to be in the eighties.[3] Every morning she woke up at 5 a.m., got dressed, and took the number 56 bus downtown to work from 8 a.m. to 4 p.m. She was home every evening by 5:30 p.m. to cook dinner. I remember my mother furiously trekking through the door in her heels, only to be minutes later standing in the kitchen in her stockinged feet, smelling of sweat and Chanel no 5, opening canned food and slamming around pots while muttering to herself about being "sick and tired" of "this." As a child, I did not know what "this" meant. As an adult, I return to the question. What is "this" that she was "sick and tired" of? Although my motherhood would look very different from my mother's, I have often felt that I was also "sick and tired" of the inarticulable "this."

In my adult life, I distanced myself from my mother when I converted to Islam at 18 and elected a more "traditional" lifestyle. As a Muslim woman, I socialized with other Muslim women, and I regularly attended a "Sister's Halaqa" at our local mosque.[4] Through these socialization processes, I came to understand that there is a religious expectation for a woman to devote herself to her children and home. I found comfort and safety in that expectation and noted that Islamic scripture, sermons, and cultural adages seemed to value the mother in ways I never observed growing up. I wondered if feeling valued could have made a difference in my own mother's experience of motherhood. Over time, I became deeply reflective on whether it was truly

making a difference in my own. Muslim families share an oft-repeated saying from Islamic scripture which translates as "Paradise is under the feet of the mother." This saying comes from a "hadith" or prophetic quotation.[5] In another hadith, the Prophet of Islam is asked who is the most deserving of respect after God and the Prophet. He answers that the mother is three times more worthy of respect than the father. Scholars of Islam explain that these hadiths, or prophetic sayings, are meant to highlight the importance of obeying and revering one's mother. As a new mother, I found comfort in these teachings. However, as I read and listened to the teachings of various (male) Islamic religious scholars and speakers, I learned that this status seems to be contingent upon the woman's performance of motherhood. I attended Islamic sermons and study groups that emphasized the mother's crucial role in guiding her children toward moral and righteous behavior. For example, Islamic male scholar Sayyid Muhammad Sohofi states:

> The rights which have been determined in Islam for a mother, and some examples of which have already been mentioned, are due to the pains she has borne in developing the life and body of her offspring, so that after tolerating such back-breaking pains, she may offer a well-bred human being to the society. Naturally, only such a mother, who performs her motherly duties perfectly, and brings up a useful and competent individual with her overall efforts, can enjoy these rights (2021, para 23–22).

In other words, Islamic scripture grants mothers the utmost respect and honor, however, Islamic scholars explain that this honor comes with lofty expectations. Consequently, I have often been consumed with guilt and a sense of failure in my own mothering. For decades I noted similar feelings expressed amongst the Muslim women around me. There is a gulf between this purported idealized status of the mother and the actual life being led by myself and other mothers.

Thus, my fascination with Muslim mothers is born of a desire to examine how we carry these expectations of the Islamic religion and reconcile them within the context of our own lives. For almost 30 years, I have socialized with other Muslim women. I have observed that the reality is that many married U.S. American Muslim women work outside the home either by necessity, expectation or to have a sense of purpose. I have observed that even if Muslim women work outside of the home, it seems that she is still often the one who is responsible for the care of the home and children. It is often mothers who are responsible for arranging playdates and transporting children to their activities. Such observations are reflective of data gathered by the Bureau of Labor

Statistics (2015) which indicates that seventy-nine percent (79%) of working American mothers are responsible for housework and child-care duties. I have wondered how these contemporary circumstances are reconciled with traditional Islamic expectations of motherhood. Such observations have led me to continuously wonder about myself and my Muslim sisters: Who are we as mothers? Who are we as *Muslim* mothers? How are we making sense of ourselves?

The Problem

In my own religious studies as a Muslim woman, I note that discussions of mothering and motherhood are dominated by male religious scholars and based on a scriptural interpretation of Qur'an and hadith. Narratives from actual women seem to be almost completely absent from the conversation. Thus, as I conceptualized this project, it was important to me to place the perspectives of actual Muslim mothers at the center of my research. Eventually, I interviewed nine Muslim women from my own faith community. Our shared identities as women, mothers, and Muslims fostered a sisterhood and camaraderie that enriched this project. As U.S. American Muslim women, we are under tremendous pressure to conform to certain expectations of motherhood, yet there is limited research on our actual experiences as mothers.

Current research includes theoretical conceptions of Muslim motherhood (Oh, 2010, 2016; Wadud, 2006), community practices of Muslim motherhood (Cheruvallil-Contractor, 2016; Curtis, 2016; Elegbede, 2016; Rouse, 2004), mothering in the context of racism and Islamophobia (Lacassagne, 2016; Lingen-Ali, 2016; Shirazi, 2016), mothering amid war and displacement (Bazaz 2016; Fox, 2016; Sinno, 2016) and Muslim women's practices of birth control and family planning (Al-Attas, 2016; Isgandarova, 2016; Nurmila, 2016). Of these studies, there are only two studies that locate Muslim mothering in the United States. Curtis (2016) examines an ethnic community of Turkish mothers and grandmothers who share parenting through traditional practices. Shirazi (2016) focuses on experiences of racism and Islamophobia endured by Muslim mothers.

The limited number of studies on U.S. American Muslim motherhood practices is reflective of an overall lack of diversity within scholarship on motherhood. Scholars point out that studies on motherhood have traditionally been oriented toward the experiences of White middle-class academics

and do not represent the experiences of all mothers (Collins, 2008; Kawash, 2011; O'Reilly, 2006, 2010; Pappano & Olwan, 2016; Takseva, 2018). These scholars lament the homogeneity of traditional scholarship theorizing motherhood and call for a greater diversity of studies.

Researchers also note that motherhood, as a theoretical object of study, has been sidelined in the margins of academia over the last two decades (Kawash, 2011; O'Reilly, 2006, 2010; Takseva, 2018). Motherhood is not treated as an object worthy of scholarly inquiry. Takseva (2018) suggests that this may reveal the inherent sexism in academia. According to the most recent census data, there are two billion mothers in the world, of whom 85.4 million live in the United States. Diminishing mothers as a population unworthy of inquiry "calls into question some of the fundamental premises of feminism and women and gender studies regarding issues of representation, inclusion, and social and gender justice" (Takseva, 2018, p. 179). Relatedly, Patricia Hill Collins (2008) has identified an "antifamily" bias in traditional feminist scholarship which results in an "antimother" bias that acts as a serious impediment to theorizing black motherhood (p. 175). I argue that this "antimother" bias has implications for studying all other forms of motherhood that fall outside the White, middle-class paradigm.

About This Project

The purpose of this qualitative case study is to explore U.S. American Muslim mothers' communicative experiences of identity. This study illuminates how national, religious, and cultural identities intersect to affect women's experiences of motherhood. The participants of my study are all U.S. American Muslim women. Although they come from a range of different ethnic and racial backgrounds, they are all members of the same mosque community in a mid-southern region of the United States. All mothers are married and are mothers to at least one child. A shortcoming of this project is that it does not include divorced or never married mothers, which is a possible direction for future research.

There are four primary goals of this project. The first goal is to capture how respondents describe and discuss their identities as mothers, wives, and Muslims. A second goal is to capture how respondents describe their relationships with their children, husbands, and other family members. A third goal is to explore contradictions, incongruences, and disruptions between how

respondents may enact (or perform) "motherhood" and their own personal feelings. A final goal is to explore the impact and influence of various overarching intersectional identities (e.g., race, class, religion).

Theoretical Framework and Research Questions

Researchers use theory as a lens to help analyze and organize information about a social phenomenon. Bormann (1989) defines theory as an "umbrella term for all careful, systematic, and self-conscious discussion and analysis of communication phenomena" (p. 25). Littlejohn (1983) considers a theory to be "any conceptual representation or explanation of the communication process" (p. 12) Littlejohn holds that theories are abstractions that organize facts, focus on important relationships between those facts, clarify observations, predict outcomes, and generates new research. In other words, theories help us to answer the "how" and "why" questions about our communication experiences (West & Turner, 2009).

This study is guided by Hecht's (1993) Communication Theory of Identity (CTI) as a means of processing the analysis. CTI conceptualizes identity in four layers: personal, enacted, relational, and communal. Personal identity describes the individual's thoughts and feelings which inform her self-image or concept of self. This identity can be captured in the respondent's accounts of how she sees herself as a mother. The enacted identity is formed through social interaction. This is the identity that the mother is expected to perform. It can be captured in explanations of what the mother does or is expected to do. Relational identity is co-created through social interaction with other community members. This identity is best understood as who a person is in relation to another person. For my research, it can be explicated by identifying instances in the discourse which refer to relationships between mother and father, mother and child, father and child, mother and grandmother, mother, and mother-in-law, or even between two mothers of the same mosque community. Finally, communal identity is "society's ascription of an identity" (Hecht & Lu, 2014, p. 4). In this case, the communal identities are "Muslim" and "woman," however, such identities could also encompass other communal identities such as "middle-class," "Arabs," "Pakistanis," "Democrats" etc. Communal identities result from members sharing common characteristics and histories. Hecht (2004) explains that communal identity can also

manifest in stereotypes (both positive and negative). For example, the negative stereotype of Muslim women as submissive and oppressed can be assumed by outsiders, while also internalized by the woman herself through media and socialization processes. In contrast, the positive stereotype of a mother as self-sacrificing, loving, and generous can offer self-esteem and a validated sense of self for women who conform to this identity.

Hecht (1993) further explains that the four layers of identity are not independent but interpenetrate; they intersect and operate jointly or at odds with each other. An individual's personal identity cannot be examined without considering how society defines the identity and how others view the identity. Sometimes the identities are in sync with each other. Other times certain identities conflict with other identities (p. 4). Jung and Hecht (2004) describe inconsistencies and discrepancies between identities as "identity gaps." For example, personal identity (internal self-image) may not align with the external enacted (performed) identity. These inconsistencies can cause emotional stress and tension for the individual. CTI is a versatile theory that is suited to this study because it posits that communication *not* only encapsulates identity, but communication *is* identity Thus, this study was guided by the following research questions:

1. How do U.S. American Muslim women discuss and describe their personal identities as "mothers?"
2. How do U.S. American Muslim women enact and perform as "mothers?"
3. How does the mother describe her relationships with the child, the father, and other family members?
4. How do larger communal identities (race, class, political affiliation) intersect to affect these participants' experiences?

My research is focused on Muslim mothers. I define "Muslim" as any person who self-identifies as Muslim and who describes themselves as following the religion of "Islam." Consequently, it is critical that I discuss and define "Islam" to avoid essentializing, making assumptions, or validating stereotypes. I resonate with three scholarly conceptions of Islam. There is Asad's (1986) approach to Islam as a "discursive tradition," Ahmed's (2015) assessment of Islam as a "cultural system," and Schielke's (2010) notion of an "every day" Islam. It is my position that none of these conceptions is truer than the other. They are all true, and all hold value in directing the goals of my research.

Defining "Islam"

Asad (1986), a cultural anthropologist, argues that any understanding of Islam must begin with its foundational texts: The Qur'an and Hadith. Qur'an is Islam's holiest book. Hadith are a collection of sayings from Prophet Mohammad. The Qur'an and Hadith represent an orthodox and authoritative Islam that is passed down from generation to generation. By "discursive tradition," Asad is referring to discourses (words, texts, and social customs) that seek to instruct practitioners of Islam toward the "traditional", correct, or orthodox form of Islamic practice. While the social world changes as time moves forward, "discursive tradition" seeks coherence and consistency. Asad challenges the Western Orientalist gaze which casts "Islam" as everything and anything that takes place in Muslim societies. Asad argues that for something to be an "Islamic" custom or practice, it must have a foundation in scripture. Consequently, I cannot dismiss the relevancy of Asad's "discursive tradition" which keeps any conception of "Islam" linked to its foundational texts. Practicing Muslims consistently return to the Qur'an and Hadith to find direction in living their daily lives as evidenced in weekly sermons, religious study circles, and shared online articles. Hamed (2016), a religious studies scholar, describes Asad's discursive tradition as an "imaginary reservoir," explaining "some of its contents shift, some spillover, some are discarded, while some become static and calcified; all according to the historical and social forces that interact to sustain and revise them" (p. 82). The reservoir is "imaginary" because it manifests differently for different Muslims (both individually and collectively).

However, Ahmed (2015), an Islamic studies scholar, disputes Asad's claim that the "domain of orthodoxy is the domain of Islam" (p. 273). Ahmed argued that while Asad disrupts the Islam versus West binary, he creates another one: a true form of Islam versus a less true form. Ahmed's conception of Islam relies on the work of Clifford Geertz who argued that religious communities represent a "cultural system." Ahmed points out that the internal worlds of individuals cannot be seen nor measured, thus one cannot determine the role of orthodoxy in constituting "Islam" in the lives of Muslims. Islamic scripture may impress itself upon the consciousness of its readers, but we can only observe manifestations of those impressions through local customs, fables, art, poetry, music, and rituals (that may or may not be tied to orthodoxy). A key component of Ahmed's cultural system is the role of the community in establishing a collective practice of "Islam" and an understanding of the "Islamic."

Ahmed acknowledges that one flaw in his idea of Islam as a "cultural system" is the word "system." The word infers an ordained, established, way of existing. Ahmed's "cultural system" is ever-changing and shifting from society to society and generation to generation. For example, since my study will focus on Muslims in the same community, it is useful to be mindful of Ahmed's notion of Islam as a "cultural system." Conceiving Islam as a "culture" underscores the collective effort that Muslims, as a community, understand and practice "Islam." For example, it is a common practice for American Muslims to send their children to "Islamic Sunday School." There is no precedent for "Islamic Sunday School" in the Qur'an, hadith, or traditional Islamic societies. We can acknowledge that this is a contemporary cultural practice that derived from the concept of Christian Sunday School which is part of Western culture. On a similar note, certain practices (including parenting practices) may come from the culture of one's country of origin (outside of the United States), but (mis)understood as "Islamic."

Schielke (2010), a cultural anthropologist, radically theorizes "Islam" as lived through everyday, mundane interactions. It is not an orthodox tradition, nor is it a distinct cultural system. It operates in the background of a Muslim's life similar to other grand ideologies like capitalism, democracy, and romance. He explains that:

> Islam, like any major faith, is not simply something: it is part of a people's lives, thoughts, acts, societies, histories, and more…it can be many different things a moral idiom, a practice of self-care, a discursive tradition, an aesthetic sensibility, a political ideology, a mystical quest, a source of hope, a cause of anxiety, an identity, an enemy-you name it (p. 2).

Schielke's approach underscores the commonality of human experience as individuals make sense of their own lives within their own context. "Islam" may not be considered a prominent part of some people's lives, but it directs its believers on how to relate to one another, how to interact, how to love, cook, parent, etc. Schielke's argument is not theoretical, but methodological. He directs researchers to locate "Islam" within the ethnographic accounts of their participants. Schielke's "everyday Islam" offers a methodological argument that directs the researcher to locate "Islam" in the everyday, mundane, accounts of respondents. Not all Muslims are practicing, and I can see Schielke's conception as potentially important in understanding how non-religious Muslims are guided by an overall religious ethic even when they are not partaking in ritual practices or ascribing to some foundational beliefs.

I take all three of these conceptions into account as I embark upon a study of Islamic motherhood: Islam as a discursive tradition; Islam as a cultural system; and Islam as the "every day" and mundane. Recognizing varying conceptions of Islam also hearkens toward an ongoing debate within the Muslim community. Whatever "Islam" is may depend on who you ask. There are those Muslims who may argue that a practice is only "Islamic" if it can be linked to scripture. Other Muslims may refer to a practice as "Islamic" because this is what they have always believed as part of their cultural upbringing, and they have no reason to believe otherwise. As a Muslim myself, I remain conscious and reflexive about how my own values and beliefs may inform or shape my analysis. Taking this approach directs me to keep my own biases in check and to recognize all forms of Muslim life experiences as equally valid forms of Islam.

About American Muslims

As I present a study on U.S. American Muslims, I am compelled to point out that U.S. American Muslims are far from a monolith. They represent a diversity of backgrounds and do not conform to one racial or ethnic group (Lipka & Hackett, 2017). The U.S. American Muslim community is significantly more racially diverse than the greater American population as a whole. Currently, there are 3.45 million Muslims in the United States, and the population is expected to grow to 2.1 percent by 2050 (Lipka & Hackett 2017). According to the Pew Research Center (2017), more than 58 percent of first-generation U.S. American Muslims over the age of 18 were born abroad, 18 percent are second-generation born in the United States and 24 percent are considered third-generation. U.S. American Muslims born abroad come from at least 77 different countries, with Pakistan being the largest country of origin at 14 percent. While 12 percent come from other South Asian countries, Middle Eastern and North African countries represent 41 percent of foreign-born U.S. Muslims or 26 percent of all Muslim Americans total. 41 percent of Muslim Americans describe themselves as White, 20 percent as Black, 28 percent as Asian, 8 percent as Hispanic, and 3 percent as other or Mixed Race.

Significance of This Study

This study interrogates the experiences of U.S. American mothers, an understudied subject, with the goal of understanding their personal, relational, enacted, and communal identities. This study marks U.S. American Muslim mothers as a category worthy of centrality and interrogation. Muslim women are often stereotyped as a monolithic group who are silenced and deprived of individual agency by Islamic religious authority (Arjana, 2018; Haddad, 2006; Said, 1978; Sinno, 2015). This study challenges these oversimplified representations by showcasing women who assert agency within their own lives despite challenges from religious and patriarchal ideologies. I spoke to nine women. Of the nine women, four identified as South Asian, two as Arab, two as White/Caucasian, and one as Black or African American. Their varying narratives of motherhood support the enduring discursive nature of Islam as a solidifying force fostering a collective identity, while also showcasing women as independent agents in their own personal and relational lives. Muslim mothers are not passive transmitters of ideology but play an active role in determining how Muslim motherhood is reproduced in the contemporary U.S. American context.

This research contributes to *motherhood studies*, defined as "the scholarly study of motherhood in all its contradictions and complexities" (Takseva, 2018, p. 178) and answers the call of motherhood scholars for a greater diversity of studies (Kawash, 2011; O'Reilly & Porter, 2006; Takseva, 2018). In *Motherhood and Feminism*, Kinser (2010) writes:

> Because dominant ideas about mothers and children are derived from white, middle-class perspectives and assumptions, it is particularly important in the study and critique of motherhood that feminists widen the lens through which we view mothers' experiences. Further, the women representing non-dominant cultures, ethnicities, and classes have faced limited access to acceptance in academic publication outlets. Consequently, much of what has been written and published about feminism and motherhood has failed to adequately examine the multiplicity of women's experiences and points of view (p. 22).

This has been particularly true in the case of U.S. American Muslim mothers. Furthermore, this study considers motherhood and mothering as worthy of scholarly interrogation.

Finally, as I undertook this project, I was compelled to reflect on how this project differs from other stories of motherhood. I came to the opinion that a

significant contribution of a study on Muslim mothers is *not only a difference but a sameness* to studies of other mothers from various cultures and contexts. It appears that women are writing one immense story from a multitude of different perspectives. Studies on motherhood include critiques of patriarchy, concerns for social justice, and discussions on the rights and agency of women.

Outline of This Book

This book is divided into seven chapters. This first chapter aimed to be an autoethnographic chapter in which I described my own trajectory of motherhood and my identity as a "mother" in relation to my identity as a Muslim. I explained that the "mother" is described in Islamic scripture as a righteous figure who deserves the reverence and obedience of her children. While Islamic scripture about motherhood is often cited as evidence of women's high status in Islam, I described a twofold problem: (a) male Muslim scholars dominate mainstream discussions on motherhood, and (b) elevating mothers to a righteous figure invokes certain kinds of gendered performances on the biological mother. The study is introduced as an effort to fill a void in the literature by offering actual Muslim women's perspectives describing their lives. The chapter highlights the vast diversity of the U.S. American Muslim population and discusses three conceptions of "Islam" to signify that there is no one way to be a "Muslim." The chapter further includes a preview of my four research questions, an outline of the purpose and contributions of the study, and a brief overview of The Communication Theory of Identity (CTI) as the guiding theoretical framework.

The second chapter, "On Motherhood, Mothering, and Islam," comprises an extended literature review on Motherhood and Islam. I cite scholars who describe motherhood as a constructed social institution that imposes itself on the identity of the mother, requiring certain identity performances. Muslim women scholars agree that motherhood is exalted in Qur'an, and Hadith, however, they call attention to how male Muslim scholars have traditionally forwarded biased patriarchal interpretations which circumscribe the mother as existing only in relation to the father. Consequently, there are Muslim women scholars who engage in "unreading the patriarchal interpretations" of the Qur'an, as they challenge them as being theologically inauthentic. This chapter also describes research on Muslim mothering, finding that Islam remains a significant identity marker in mothers' lives.

The third chapter, "Me, Mothers and this Study," describes the methodology used in this project. Taking an autoethnographic perspective, I explain how my identity as a Muslim woman and insider to my research subject served as the primary motivator. I argue for the value of insider research and explain how my relationship to the topic and my participants contribute to the value of the study. I explain the recruiting and interview procedures that took place over four months. During this time, I conducted interviews with nine respondents using an unstructured interview format. I describe this project as one in which I regard my participants as collaborators. This chapter also includes an explanation of The Communication Theory of Identity (CTI) as the guiding theoretical framework.

The fourth chapter is titled "Scripture vs Culture." This chapter is about the communal identity of Muslim mothers in this study. The chapter focuses primarily on a recurring theme that described two different mothers: the esteemed mother of Islamic scripture and the mother oppressed by cultural expectations of sacrifice and suffering. Overall, the women explained that Islamic scripture holds mothers in high esteem, however, mothers are often pressured to embody a certain conception of motherhood to earn that esteem.

The fifth chapter, "Mothers' Obligations and Fathers' Roles," focuses on relational and enacted identities. Participants describe the relationships between mother, father, and children. The Muslim family is described as one that circumscribes the roles of the father, mother, and children. Mothers are meant to be nurturing caretakers. Fathers are meant to be "protectors" and "providers." Children owe their parents respect and obedience. Mothers explain that they are "willing to sacrifice" careers, time, and personal autonomy.

The sixth chapter, "Sacrifice and Failure," considers the mothers' impressions of themselves. This section focuses on how the communal, relational, and enacted layers of identity interpenetrate to inform the personal layer. It also considers how incongruences and contradictions between identity layers resulted in reported identity gaps.

The last chapter is a "Final Reflection." I conclude this project with an extended discussion of the implications and limitations of the study and an explanation of how the research project achieved its principal goal of enhancing the understanding of U.S. American Muslim women's perspectives on Muslim motherhood. As a Muslim woman myself, it was critically important to me to successfully execute a study that centered on the perspectives of everyday Muslim women who discuss motherhood in their own words. I offer

an extended reflection on the research process and discuss my relationship with the women of the study.

Notes

1. The Meaning of Being a Mother (hellomotherhood.com).
2. Kohl is an eye cosmetic used to darken the rims of the eyes.
3. Motherhood historian Vandenberg-Daves notes that the 1980s working mothers were under tremendous social pressure to intensively mother their children due to cultural "mommy wars" which pitted stay-at-home mothers against working mothers.
4. "Halaqa" in Islamic terminology describes a religious gathering or meeting for the purposes of studying Islam and the Quran. "Sisters" implies that this gathering was for women only. These study groups were always headed by the "Sheikh" or male leader of the mosque. While being "male" is not an official requirement to lead a sister's halaqa, this was the condition of every such gathering that I have ever attended.
5. Hadith comprise what orthodox Muslims believe to be the recorded words of the Islamic prophet Muhammad. Hadith hold a high status in Islamic belief, next to Qur'an, the Islamic holy book.

· 2 ·

ON MOTHERHOOD, MOTHERING, AND ISLAM

This chapter provides an overview of "motherhood studies" and explains a distinction between "motherhood" as an institution and "mothering" as a lived experience. It includes a discussion of available literature on Muslim motherhood as described in Islamic scripture and research on the actual experiences of Muslim mothers.

Motherhood Studies

This research project is partly inspired by an area of scholarship conceptualized by Andrea O'Reilly (2006, 2010) as "motherhood studies." Motherhood studies is an interdisciplinary field with scholars who come from a wide range of areas including anthropology, sociology, religious studies, communication, and women's studies (Kawash, 2011; Takseva, 2018). It is described as the "scholarly study of motherhood in all its contradictions and complexities" (Takseva, 2018, p. 178). Foundational studies on motherhood were written from the perspectives of white, middle-class, U.S. American academics (Collins, 2008; Kawash, 2011; Takseva, 2018). Earliest works include Nancy Chodorow's *The Reproduction of Mothering* (1979), Adrienne Rich's *Of Woman Born* (1986), and Sara Ruddick's *Maternal Thinking* (1995). These early studies

were written from the perspectives of White middle-class women who saw motherhood as an oppressive social institution. "Oppressive" meaning that women were living lives "confined and shaped by forces and barriers which are not accidental or occasional and hence avoidable" (Frye, 1983, p. 4). Put simply, motherhood is likened to an ideological prison that holds women to a higher moral standard and restricts them from certain thoughts, movements, and behaviors.

It is important to clarify that Motherhood scholars are careful to make a distinction between the social institution of *motherhood*, and the lived experience of *mothering* (Kawash, 2011; O'Reilly, 2006; O'Reilly & Porter, 2006; Rich, 1976; Ruddick, 1990; Takseva, 2018). The latter has the potential to be fulfilling and rewarding. Rich (1976) argued that the institution of motherhood *imposes* itself upon the experience of mothering. She explains:

> Institutionalized motherhood demands of women maternal "instinct" rather than intelligence, selflessness rather than self-realization, relation to others rather than the creation of self. Motherhood is "sacred" so long as its offspring are "legitimate"- that is, as long as the child bears the name of a father who legally controls the mother (p. 42).

In other words, the experience of motherhood is filtered through the woman's relationship with her husband. Ruddick (1995) expands on this idea by noting how mothers are relegated to the home and private sphere. The mother is expected to perform the roles of caregiver and nurturer. These characteristics are "naturalized" as part of the woman. Consequently, the private domestic work of the mother is dismissed, taken for granted and considered less valuable. In contrast, the father occupies the public, economic, and political spheres, therefore acting as a liaison between the family and the outside world.

Non-white scholars point out that while motherhood may *seem* the locus of women's oppression, this is not true for all women, everywhere (Collins, 2008; Wadud, 2006). Scholars on African American motherhood highlight the power and influence that mothers play in their communities (Collins, 2005, 2008; Craddock, 2015; Dow, 2016; hooks, 1990). They note that while many White feminist theorists highlight the problems that arise when parenting is done by one individual, they ignore the role of women-centered communities amongst African Americans (Collins, 2008; hooks, 1990). Notably, hooks (1990) describes visiting her "grandmother's house," even though her grandfather lived there too. She explains:

> In our young minds, houses belonged to women and were their special domain, not as property, but as places where all that truly mattered in life took place: the warmth and comfort of shelter, the feeding of our bodies, the nurturing of our souls. There we learned dignity and integrity. We learned to have faith. The folks who made this possible, who were our primary guides and teachers were Black women (p. 383).

hooks (1990) explains that Black women are tasked with creating and sustaining home environments that served as a refuge for their husbands and family members from the reality of racial oppression and White domination. hooks (1984, 1990) also notes that while early feminists demanded respect and acknowledgment for housework and childcare, they did not attribute enough value to the significance of childbearing and motherhood.

Furthermore, Collins (2008) argues that mainstream academic theorizing about motherhood dichotomizes family life into public and private. The female occupies the private domestic sphere and assumes the male is a dominating force in the public sphere and political economy (p. 311). This is simply not the condition for all mothers and families. Collins explains:

> While male domination certainly has been an important theme for racial ethnic women in the United States, gender inequality has long worked in tandem with racial domination and economic exploitation. Since work and family have rarely functioned as dichotomous spheres for women of color, examining racial-ethnic women's experiences reveals how these two spheres are actually intertwined (p. 312).

In other words, White feminist scholars have historically forwarded a very narrow vision of motherhood that assumes women stay in the home and men work outside of the home. They did not consider the circumstances of poor and minority women compelled to join the workforce for economic survival (Collins, 2008; hooks, 1984).

Scholars further discuss the power and influence Black mothers play in their communities and name Black motherhood as a space where Black women learn self-definition, empowerment, and respect (Collins, 2005, 2008; Craddock, 2015; Dow, 2016; hooks, 1984, 1990). To be clear, the centrality of the mother is not characterized by the absence of husbands and fathers. Men are present and have significant roles in the family (Collins, 2008).

Overall, non-white scholars draw attention to the unique circumstances that face mothers of racial and ethnic minorities. Collins (2005, 2008) asserts that motherhood practices of minority women in the United States cannot be examined in isolation from "specific historical situations framed by interlocking structures of race, class, and gender." Motherhood scholars lament

the lack of diversity in motherhood scholarship and argue that this problem is reflective of an overall reluctance of academics to engage with the subject of motherhood at all (Collins, 2005, 2008; Kawash, 2011; O'Reilly, 2010; Takseva, 2018). Takseva (2018) suggests that the "distinctly negative stance toward motherhood" is due to an assumed link between women's oppression and large social structures (p. 179). She explains:

> The imaginary boundaries established around the field of women and gender studies are still constructed upon the assumed link between women's oppression in relation to larger social and political structures, including the assumed normative presence of the nuclear family and the public-private dichotomy. This essentialist form of thinking rests on the notion that gender-neutral individualism defines or should define feminist subjectivity, which renders motherhood problematic (pp. 179–180).

Thus, it is impossible to theorize motherhood without engaging with the gendered and relational dimensions of one's identity. Takseva (2018) cites Collins (2005) as identifying an "antifamily" bias which has resulted in an "anti-motherhood" bias in mainstream academic scholarship. The dearth of scholarship on motherhood became a source of frustration in my own search for relevant literature on Muslim motherhood and the experiences of Muslim mothers as explored in the next section.

Defining Muslim Motherhood

Stories from Qur'an and Hadith exalt both biological and non-biological mothers independent of their relationship to a husband or father figure (Upal, 2005; Wadud, 2005; Oh, 2010; Pappano & Olwan, 2016). Notably, many of the women in the prophet's household were not biological mothers but hold a high status in Islamic tradition as the "Mothers of the Believers" (Cheruvallil-Contractor, 2016, p. 15). Scholars further note that wet nurses were a normal part of medieval Arab culture during the dawn of Islam. Children breastfed by the same wet nurse were considered siblings and could not marry one another. Oh (2010) points out that wet nurses are described as "performing moral work that deserves divine reward" (p. 642). In all these examples, the "mother" transcends her reproduction function. According to the Qur'anic story, there is no husband or father figure in the story of Prophet Isa (Jesus). Prophet Isa (Jesus) is referred to not as the son of God, but as the "son of Mary." Asiya, the wife of Pharoah, who cared for Musa (Moses) after her servant discovered him in the water, is treated as a virtuous and noble figure for raising Musa (Moses)

in her household although she is not his biological mother. She defies her husband, Pharoah, to protect and care for Musa (Moses), including recruiting his birth mother to nurse him. Pappano and Olwan (2016) point out "Mariam and Asiya are considered the two most venerable women in the Qur'an, and, notably, in these two figures, motherhood and mothering are both completely independent of fathers and form the basis of their special status" (p. 6).

Similarly, Wadud (2006) addresses the question of gender and family in Islam with an examination of Hajar, framing her story in the historical context of the time. Hajar, the concubine wife of Prophet Ibrahim (Abraham) is abandoned in the desert at the request of a jealous Sarah, where she is left to raise Prophet Ismaeel (Ishmael) alone. Wadud argues that whether slaves or wives, women were perceived as biological "vessels" to carry offspring and continue the paternal family line. In turn, women (wives or slaves) were guaranteed the protection of the patriarchal household they belonged to. Thus, Wadud asks what does it mean when the Quran tells us a story of an Egyptian slave woman abandoned by the father of the Abrahamic religions and compelled to raise her child in the desert as a single mother? What does the lack of scholarly examination of this story suggest? Wadud argues that male Muslim scholars have historically framed "motherhood" in relation to patriarchy and consequently have blind spots when it comes to developing an authentically Islamic conception of motherhood. To critically examine the story of Hajar (and reflect upon it) is a disruption to the traditional construct. "Motherhood" is idealized only to the extent that it constitutes the role of "father." Consequently, Islamic discourse has largely ignored the lived realities of Muslim mothers (Wadud is specifically concerned with African American Mothers). Wadud posits a new paradigm- one that expands the conception of family and of *motherhood*. Wadud argues that a deeper analysis of Hajar's role in Islamic history hearkens toward an expansion of the idea of family and a reconstruction of the Muslim Mother. The nurturing mother is also a housekeeper, cook, laundry woman, educator, personal driver, and medical assistant. She is also a woman who must contend competitively with the patriarchal public sector to provide financial sustenance and protection to ensure her family leads a life of safety and dignity.

Furthermore, Upal (2005) argues that the Qur'anic mother is not limited to her reproductive abilities but includes the qualities of "leading humankind, showing exemplary dedication, compassion, and caring for the overall well-being of others" (p. 86). Upal asserts that a Muslim mother is not defined only by her relationship with her children, but by her relationship with God and

is judged by her service to her entire community. Schleifer (1986) posits that in early Islam mothers understood that they had a responsibility to impart Islamic knowledge to (not only) their children but to their community and the future generation.

Asma Barlas (2002) seems to suggest that not only are mothers and fathers *not* equal in the Qur'an but that mothers are elevated to a *higher* status than men. Rejecting a divine patriarchal order of the world, Barlas explains:

> ... the Qur'an also elevates mothers over fathers and makes reverence for mothers a sign of righteousness, not just an expression of sentimentality...even though the Qur'an does not describe the mother's rights in the same terms in which patriarchies define the father's rights (as ruling over children or spouse), it gives mothers a real and symbolic status that patriarchies do not, and it does not give fathers the same status that patriarchies do (p. 179).

Barlas (2002) further claims that the Qur'an brings mothers into the same symbolic signification that is reserved for God. Barlas makes clear that she is not suggesting that reverence for God is equal to that of mothers but claims that the fact reverence is extended to mothers (and not fathers) is proof that Islam privileges mothers in a way that it does not privilege fathers.

Status of Mothers in Islam

To contextualize this study and understand how motherhood functions as a social institution in the lives of Muslim women, it is necessary to review what Islamic scripture states about mothers and how these statements are interpreted, discussed, and debated amongst Islamic religious scholars. There are two adages, or "sayings", that Islamic religious scholars reference as proof of a mother's high status in Muslim families and Islamic families: "Paradise is under her feet"; and "Mothers are owed three times the respect." Both sayings are based on hadith and are further discussed in the next section.

Paradise is Under Her Feet

Scholars writing about Muslim mothers all acknowledge that mothers retain a high social standing in Islamic sacred text and scripture as echoed through an adage that reverberates throughout Muslim societies: "Paradise lies at the feet of the mother" (Curtis, 2016; Oh, 2010, 2016; Pappano & Olwan, 2016; Schleifer, 1986; Wadud, 2006). This adage is based on the following hadith:

> A man came to the Prophet and said: 'O Messenger of God, I want to go out and fight (in Jihad) and I have come to ask for your advice.' He said: 'Do you have a mother?' He said 'yes'. The prophet said: 'Then stay with her, for Paradise is under her feet.'"[1]

Islamic scholars explain that this hadith means mothers are to be revered, respected, and even feared. Elegbede (2016) notes that this hadith is cited as evidence that mothers should be honored above all others, after God. Upal (2005) further notes that God's attributes, as the Creator of humanity, are directly connected to the mother's womb as the site of creation. It is the place where the corporeal body is formed and where the soul enters. Specifically, there are ninety-nine names attributed to God, and of them is "Ar-Rahman" translated as "The Gracious". This attribute describes a generous God that gives and gives without ever being asked. The word "rahm" is the Arabic word for "womb" (Upal, 2005). Curtis (2016) explains:

> Simply put, the idea is that the nurturance and selflessness that is part of mothering is close to godliness and that mothers will reap the rewards of their labor for eternity in heaven (p. 153).

Thus, women are second only to God in the qualities of generosity, caring, nurturing, and compassion (Curtis, 2016; Upal, 2005).

Three Times the Respect

Schleifer (1986) cites Al-Qurtabi as indicating that the mother is owed three times the kindness, compassion, and obedience, as that of the father. This direction is based on the following hadith:

> "A man came to the Prophet and said: "O Prophet of God! Guide me, to whom should I be good in order to benefit completely from my good deed?" He said: "Be good to your mother." He asked: "Next to her?" The Prophet repeated: "Be good to your mother." He said again: "And next to her?" The Prophet answered: "To your mother." The man said: "To what other person should be good?" The Prophet said: "To your father."[2]

Schleifer (1986) explains that the relationship between the child and the mother is the highest order of all human relationships. The mother is mentioned three times before the father, meaning that she is to be obeyed and respected three times more. Schleifer (1986) holds that the child has physical, emotional, and spiritual obligations toward the mother that are ongoing and

extend until even after her death. This means that a child should continue to pray for their mother and give charity on her behalf for as long as the child is alive.

Patriarchal Appropriation of Mother's High Status

In recent decades, women Islamic Studies scholars have pointed out that verses meant to exalt the Muslim mother are appropriated to privilege and affirm a patriarchal family structure that disadvantage the mother (Barlas, 2002; Oh, 2010; Pappano & Olwan, 2016; Wadud, 2006). In other words, male scholars have translated and interpreted Islamic texts about motherhood to serve the needs and interests of husbands and fathers. To understand "patriarchy", we can turn to the 1976 explanation by Adrienne Rich. In her foundational work *Of Woman Born*, she describes the patriarchy as:

> ...the power of the fathers: a familial-social, ideological, political system in which men-by force, direct pressure, or through ritual, tradition, law, and language, customs etiquette, education, and the division of labor, determine what part women shall or shall not play, and in which the female is everywhere subsumed under the male. (p. 57).

Thus, while mothers are granted high status in Islamic scripture, there are conditions attached to this status. This point is perhaps best exemplified in an examination of the earliest English-language work on Muslim motherhood: Aliah Schleifer's 1986 *Motherhood in Islam*. Schleifer, a professor of Islamic studies, writes that the high status of Muslim mothers does not occur in a vacuum but is:

> based on her exhausting efforts in the bearing and rearing of her children...Islam views successful motherhood as the perfection of the Muslim woman's religion- that there is no better or healthier substitute for a mother's affection and concern for her children, as expressed in nursing them and just being there when she is needed... Motherhood, in fact, is the special vehicle by which she attains respect in life, and which ultimately heads for her just reward (pp. 88–89).

In other words, there are specific obligations that a mother must fulfill to earn her exalted status. The book includes an endorsement from Islamic studies Professors Ahmed Ghunaim (who is also the author's husband) and Professor

Mohammed Al-Battawy from Al-Azhar University in Cairo, Egypt.[3] In the book's foreword, Al-Battawy posits that the author has described the "perfect" Muslim mother who includes the characteristics of "sacrifice, affection, and self-denial". Schleifer compares motherhood to martyrdom, stating that is the woman's chance to suffer "for the sake of Allah" (p. 3).

Supporting Schleifer's conception of motherhood, Al-Faruqi (2000) explains that the Qur'an clearly differentiates between the rights and obligations of the father, mother, and child to maintain the social fabric of society. The child is vulnerable and helpless, thus "its rights must be protected, which creates a series of obligations toward it that must be fulfilled" (pp. 79–80). Al-Faruqi (2000) further highlights the Qur'an as taking the family unit as the starting point of social order, rather than the individual. The mother faces certain "natural obligations" due to "biological laws" (p. 80). Beyond her role of childbearing and breastfeeding, she should also exhibit a willingness to place the needs of her husband and children above her own. The mother has obligations to provide her children with religious education and teach them obedience and moral conduct. Furthermore, while the child owes their obedience to the mother, the mother owes her obedience to her husband. In turn, the father must financially provide for the family (Al-Faruqi, 2000, p. 80). Haddad (2006) notes that amongst "conservative Muslims," a Muslim mother is "expected to set aside any personal aspirations until her husband's and children's needs are met… mothers are to be exemplary in their piety and a foundation of Islamic education for their children" (pp. 34–35).

Cheruvallil-Contractor (2016), Pappano and Olwan (2016), and Wadud (2006) disagree with Schleifer (1986). They point out that the actual Islamic scripture is not clear about defining the characteristics of a mother. Cheruvallil-Contractor (2016) notes that a critical reading of the Qur'an and hadith demonstrate that "these core texts are silent on what motherhood should entail for a woman. They do not set 'dos and don'ts' and certainly do not insist on a particular mold that Muslim mothers should conform to…" (pp. 17–18). Wadud (2006) specifically calls out Schleifer arguing:

> Aliah Schleifer built a case around the concept of motherhood as one of sacrifice and martyrdom. The evidence for the case is very skeletal…When we extol selflessness as a particular virtue of the mother- but not as a general category of virtue for all humans- we are setting up a standard of motherhood that's exceptional to other human functions, even within the family. We have an entire array of virtues and values of 'mothering' that become a special prison for women who try to emulate them (p. 128).

Wadud (2006) echoes the sentiments of Rich (1976), by describing the patriarchal conception of motherhood as a "prison" that restricts women from certain thoughts, feelings, and behaviors.

Overall, while scholars agree that Islamic scripture extols the mother, they disagree on whether mothers must fulfill certain conditions to earn that status. Women Islamic scholars have emerged in recent decades to challenge normative interpretations of Islamic scripture which they claim privilege the nuclear family and circumscribe the role of mothers as existing in relation to the father (Oh, 2010; Pappano & Olwan, 2016; Wadud, 2006). They argue that male Muslim scholars have historically framed "motherhood" in relation to patriarchy and consequently have blind spots when it comes to developing an authentically Islamic conception of motherhood. Wadud (2006) specifically cites colonialism and neoliberal politics as influencing these interpretations, arguing that motherhood cannot be separated from the historicity that surrounds it. She explains that it is an institution constructed over time, shaped, and upheld by different social systems, naming patriarchal religion as being one of the most powerful.

Muslim Mothers Mothering

While there is a prolific amount of literature that focuses on the scriptural exaltation of mothers, there is much less attention paid to the actual experiences of Muslim mothers and the role that Islam plays in their mothering identities. Before 2016, the only mention I find of Muslim mothering experiences is embedded in a larger ethnographic study of Muslim women, in anthropologist Rouse's (2004) *Engaged Surrender*. All other literature focused exclusively on Muslim mothering practices do not emerge until after 2016. Pappano and Olwan's 2016 edited collection titled *Muslim Mothering: Global Histories, Theories, and Practices* mark an effort to fill that gap. The edition is divided into the following sections: Muslim mothering practices amidst war and violence (Bazaz, 2016; Fox, 2016; Sinno, 2016); in non-traditional family structures (Curtis, 2016; Elegbede, 2016; Pappano, 2016); within the diaspora (Lacassagne, 2016; Lingen-Ali, 2016; Shirazi, 2016); and the impact of Islam on reproductive and maternity rituals on Muslim mothers of various cultures (Al-Attas, 2016; Isgandarova, 2016). Two other studies on Muslim mothering include Cheruvallil-Contractor's (2016) examination of motherhood narratives of South Asian Muslim women in Britain and Hamed's (2016) study

on the imaginations of Muslim women in the Greater Toronto Area (GTA) focusing on their assumed religious and educative responsibilities toward their children.

Within these readings, I found a common theme of mothers constructing empowered identities in various life circumstances. The only exception is Hamed's 2016 study which refers to Muslim mothering as a disempowering identity, as the women of the study shared a common sentiment of feeling that they were falling short and failing their children. The next sections are organized around four themes: empowered mothering in non-traditional family structures; empowered mothering amidst trauma; empowered mothering as a community experience; and Muslim mothering as a disempowering experience.

Empowered Mothering in Non-traditional Family Structures

As discussed in a previous section, normative Islamic sources privilege the patriarchal family unit while considering all other familial arrangements deviant. Wadud (2006) points out that Islamic family law is predicated on the assumption that men provide protection and material resources to their wives and children, rendering the experiences and challenges of unmarried Muslim mothers as invisible. Elegbede's (2016) and Lingin-Ali's (2016) studies focus on such women. They are divorced, single mothers in female-led households. In Muslim-majority societies, single and divorced Muslim mothers are often assumed neglectful of their husband's and children's needs, materialistic, career-oriented, selfish, and deficient in religion (Elegbede, 2016; Nurmila, 2016).

Yet these studies show that divorced and single mothers look to Islam as a source to construct defensive arguments against their social marginalization and stigma (Elegbede, 2016; Lingin-Ali, 2016). Women reject what they cite as "old-fashioned interpretations and cultural corruptions" and regain social capital by (re)constructing religious identities (Elegbede, 2016). Participants in Elegbede's study on single mothers in Kuala Lampur, Malaysia shared their feelings that a Muslim woman needs the experience of divorce to fully understand the liberatory framework of Islam. Elegbede explains that the divorced women in her study "recode daily mothering activities by infusing them with personal, social, and religious meanings, by reclaiming their place at the center of social and national development, and by gaining social capital" (p. 99). Specifically, the divorced women in Elegbede's study go to work and run home

businesses and claim that financially providing for their children is part of their duty as a "good" Muslim mother. These women expend financial, emotional, and physical resources in caring for their children and view their life struggles and personal sacrifices as their "religious duty" (104). The mothers in Lingin-Ali's (2016) have fled marriages characterized by domestic violence. These mothers see themselves as responsible for the protection of their children (as opposed to the father) and have recoded their actions as a religious obligation of a "good" mother.

Empowered Mothering to Deal with Trauma

A review of the literature also finds that Muslim mothers tend to display empowered identities to cope with mothering amidst war and violence (Bazaz, 2016; Sinno, 2016). In these situations, Islam is cited as a source of comfort and direction. Bazaz (2016) examines the trauma narratives of Muslim mothers parenting alone in war-torn Kashmir. Bazaz (2016) found that the role of faith and Islam is a central component in women's lives. One woman did not have food for herself or her children for days after her husband disappeared, yet she reports being comforted by the presence of God. Other women of Bazaz's study explain that only God or the Prophet Muhammad were witnesses to their pain and understand the extent to which they suffer. Their Islamic faith provides emotional and spiritual consolation. The mothers of Bazaz's study are women who have been brutalized physically, and mentally. Many have had their sons or husbands arrested or killed. Yet, these women encourage other Muslim mothers in their situation to "bear the pain" (p. 66). Bazaz explains that she understood that "bearing the pain" is not a "passive acceptance or victimization but as an active struggle to survive: an intention each day to not crumble…" (p. 66). These women draw on their religious faith for the strength to endure.

Sinno (2016) more directly discusses the construction of an empowered identity in her analysis of Laila El-Haddad's internet blog posts. Also known as "Gaza Mom", El-Haddad documents her mothering experiences in Palestine, while navigating border closures, recurrent bombardment, and intense political upheavals. Sinno coins the term "empowered Muslim mothering" to describe El-Haddad's mothering practices. The term is partly inspired by O'Reilly's (2004) descriptions of "empowered mothering". Empowered mothers live their lives from a "position of agency, authority, authenticity, and autonomy" (p. 12). It is a practice of motherhood that is distinct from

"patriarchal motherhood" and encapsulates a mother who views herself and her child as tasked with enriching the life of the other. Sinno (2016) notes that El-Haddad's access to social media allows her to exercise power and agency through writing and anti-war activism while parenting her young son. Sinno tells us that a reader of El-Haddad's blogs will note that her steadfastness in the face of war and chaos are "informed by two main facets of her identity, namely her Islamic faith and her motherly status" (p. 25). For example, Sinno describes El-Haddad as discussing how breastfeeding her young son (as recommended by the Qur'an to take place up to two years) had gotten her through numerous border crossings. The ability to feed her child becomes a powerful act of resistance. Sinno argues that although El-Haddad has no control over the border, breastfeeding grants her a sense of agency over her and her son's "body and soul" (p. 26). In another example, Sinno describes a conversation that El-Haddad has with her young son who expresses fears that his grandfather will die in a bombing. El-Haddad responds to her son by directing him to trust God and pray for his grandfather's fate.

Empowered Mothering as a Community Experience

Community relationships and kinship networks play a significant role in the lives of Muslim mothers (Cheruvallil-Contractor, 2016; Curtis, 2016; Lacassagne, 2016; Pappano & Olwan, 2016). In Curtis's (2016) study, Turkish women living in the United States form kinship networks based on a shared national identity and their status as members of the same religious community. These women adopt the norms of their traditional practices to face the social realities they face in the United States as outsiders to their community. Curtis describes these women as having deep attachments to their original cultures. They are invested in the idea that the ideal Muslim community is built by "living by example" (p. 142). For these women, mothering in the diaspora presents specific challenges. For example, the medical practices and the education systems are different from their own countries, and they do not have the support of their own families to help navigate such changes. One participant of the study explained that living abroad in the United States caused her to feel that she had two families: "one cobbled together out of friends and acquaintances in the United States, in addition to her family back home in Turkey" (p. 145). These women transgress traditional expectations of motherhood by working outside of the home, pursuing Islamic education, and

doing volunteer work within their larger community- all while also maintaining the expected domestic work ethic inside of their homes.

Lacassagne's (2016) study of immigrant mothers in a northeastern Ontario city, finds that the practices of motherhood prevent isolation in the lives of women experiencing discrimination. She notes that mothers, representing various "alienating positions" must "circulate, create their own space, and find ways to survive and flourish" (p. 176). Their community relationships function as a "third space" that allows women to make sense of their lives amidst competing and often contradictory discourses (e.g., Islamic, secular, Orientalist, etc.) (Khan, 1998). Bhaba (1994) explains that "this third space displaces the histories that constitute it, and sets up new structures of authority, new political initiatives, which are adequately understood through received wisdom" (p. 211). In other words, due to their outward Islamic identity, Muslim women are marked as "other" in their neighborhoods, interfaith circles, and their children's schools. They are constantly negotiating their identities in public communities. They are more closely scrutinized, and their motherhood is held to higher standards. They have interactions that are displacing, alienating, and require a high degree of emotional labor. Thus, the third space functions as a space for safety, openness, community, and freer expressions of identity.

While not explicitly about Muslim mothering, Rouse's (2004) study focuses on a community of African American Muslim women in Southern California. The women of the study construct empowered personal identities directed by Islamic principles. They create a community founded on a religious faith they interpret as antithetical to the racist/sexist values of American culture, Western Feminism, and White American Christianity. Commitment to Islamic principles of egalitarianism rid these women of internalized self-loathing and gives them a sense of value and power. Specifically, these women are engaged in their own exegesis of the Quran. They locate meanings that speak to their own lived realities that grant guidance, comfort, and positive self-identities. For example, while there is a call for women to submit to traditional gender roles, there is a heightened emphasis on the responsibilities of the father (as opposed to the obligations of the mother). Women are described as "so special in Islam" that she does not have to worry about economic responsibility (p. 51). Overall, these women assert control over the meanings behind gender roles, family, authority, rights, and responsibilities within a marriage. The children of these mothers attended a private elementary school attached to the mosque. The school went beyond educational basics and included curriculums on African American history, Islamic history, Qur'an, Arabic, and

classes on the rituals of the Islamic faith. The mothers volunteer at the school and take an active role in their children's education.

Muslim Mothering as Disempowering

However, not all Muslim mothers take positive inspiration from Islamic constructions of Motherhood. Hamed (2016) highlights the impact of the adage "the mother is a school." The adage is based on poetry from the Egyptian Hafiz Ibrahim. Hamed (2016) explains that this adage is oft-repeated- not only by Egyptians in Egypt but by Muslims everywhere in both Arab and non-Arab lands. In Hamed's (2016) study of eleven mothers in the Greater Toronto Area, she finds that conceptualizing the mother as a school is disempowering and burdensome. Hamed describes her study participants as feeling though they were failing as both mothers and Muslims. She finds that the metaphor of the school places an unrealistic burden on the mother to remain in a static state of religious idealization. Hamed argues that true spirituality is characterized by an oscillation between remembrance and forgetfulness. A religious person remembers their Lord, but then they forget and fall into sin. They then remember and repent. If the mother is a school, then she is in a "frozen state" of remembrance (p. 82). Hamed explains "although the rest of humanity can err and repent, forget and remember, the Muslim mother must be an exemplar of piety at all times" (p. 87).

Consequently, the women of Hamed's study did not consider themselves "religious" or "spiritual" enough to have imparted a proper Islamic education to their children. The women described feelings of guilt and inadequacy. Conceptualizing the mother as a school creates an unreasonable expectation that alienates women from religious growth. The source of the mother's own fluctuating spiritual state can become a source of confusion and anxiety. Hamed explains, "these mothers are not schools because according to them, that ideal is unreachable. They imagine themselves at a more distant point in which they long for what is mostly unattainable" (p. 90). Hamed concludes that she and other mothers like her resist the conception of the mother as a school because it is dehumanizing.

Final Thoughts on Muslim Mothering

Overall, the literature covers a range of experiences and demonstrates that there is no single snapshot of "Muslim mothering." With 1.6 billion Muslims in the world, Muslim mothers most certainly encompass a vast diversity of racial, ethnic, and national identities. As Pappano and Olwan (2016) explain:

> Muslim mothering, like all forms of mothering, can elicit a range of experiences and emotions that are themselves marked by contradictions, tensions and even ambivalence…Although many Muslim mothers look for guidance to the traditional sources of Islamic authority, the Qur'an, hadith, and tafsir, mothering practices necessarily draw heavily from diverse and multiple cultural and familial experiences and national contexts as well (p. 2).

Additionally, Muslim mothers' experiences will be influenced by additional factors such as their national identity, their status as first, second, or third-generation immigrants, their socio-economic conditions, their community and family structures, their educational level, and the degree of their own religiosity (Cheruvallil-Contractor, 2016; Pappano & Olwan, 2016). Yet, even with such a diversity of identities, Muslim mothers, or specifically Muslim women, are rarely portrayed in media. Muslim women are characterized by their absence rather than by their presence (Arjana, 2018; Haddad, 2006; Said, 1986; Sinno, 2015). When they are portrayed, they are often reduced to "passive victims, escapees, or pawns" (Sinno, 2016). Haddad (2006) explains that the depiction of Muslim women in Western media has traditionally been "primitive, unenlightened, and subjugated" (p. 22). Pappano and Olwan (2016) quote Leila Abu-Lughod (2008) as stating that there is:

> Almost unquestioned consensus that Islam is the ultimate determinant of women's lives in a part of the world closely associated with the Middle East, but extending to South, Southwest, and Southeast Asia. The "Muslim woman" is a trope of great symbolic power, restricted by her veil or burqa, under the thumb of religion and her man (xvi).

Overall, Muslim mothers, like most mothers, live in patriarchal societies, however they do not necessarily name Islam as the source of oppression. On the contrary, Muslim women tend to reconfigure and challenge normative conceptions of Muslim motherhood in their own lives, challenge traditional interpretations, and cite Islam as a source of power, comfort, and/or direction

(Bazaz, 2016; Curtis, 2016; Elegbede, 206; Lacassagne, 2016; Lingin-Ali, 2016; Sinno, 2016).

In summary, scholars differentiate between motherhood and mothering. Motherhood is defined as a constructed social institution that imposes itself on the identity of the mother. Muslim women scholars agree that motherhood is exalted in Qur'an, and Hadith, however, they call attention to how male Muslim scholars have traditionally forwarded biased patriarchal interpretations which circumscribe the mother as existing only in relation to the father. Consequently, some Muslim women scholars engage in unreading the patriarchal interpretations of the Quran, as they challenge them as being theologically inauthentic.

Research on Muslim mothering finds that Islam remains a significant identity marker in mothers' lives. For some Muslim women, the Muslim identity is a source of distress that invites discrimination and spiritual disillusionment. Other Muslim women tend to reinvent the Muslim mother identity differently than the predetermined patriarchal construct. Such mothers find autonomy and liberation through "Islamic' ways of living and being in the world and share a common theme of underscoring how Muslim women recognize Islamic ideals as inherently egalitarian and justice-oriented. Overall, Muslim women sense a contradiction between the tenets expressed in the Quran and the reality of their lived experiences. Cheruvallil-Contractor (2016) cites Audre Lorde's (1984) famous metaphor by positing that Muslim mothers use "the master's tools to dismantle the master's house" (p. 26).

Notes

1 This hadith is recorded in Sunan an-Nasa'i 3104 Volume 1, Book 25, No. 3106.
2 This hadith is recorded in Sahih Bukhari, Volume 8, Book 73, No. 5.
3 Al-Azhar University is the second oldest degree granting university and is world-renowned as the most prestigious university of Islamic Studies. Source: Roy, Olivier (2004). Globalized Islam: The Search for a New Ummah. Columbia University Press.

· 3 ·

ME, MOTHERS, AND THIS STUDY

This chapter focuses on the methodology I used in my study. Methodology refers to the general research strategy that outlines the way a research study was undertaken (Howell, 2013). In this chapter, I first discuss my positionality as a U.S. American Muslim woman researching other U.S. American Muslim women. I reflect on my relationship to the research topic and the reasons I decided to study motherhood and mothering experiences amongst my peers. Next, I include an overview of research methods and explain why an intrinsic, exploratory, case study is the most appropriate approach. I discuss how my analysis was guided by critical discourse analysis (CDA) and connected to the Communication Theory of Identity (CTI) as the theoretical framework. The final part of this chapter includes details about the research site, participant selection, interview protocols, researcher reflexivity, and validity procedures.

Me

Although I was not raised as a Muslim, I began identifying as one at the age of 18. I was raised by a white U.S. American father and an immigrant Thai mother in a historically African American neighborhood. Despite living in the "bible belt," neither of my parents followed an organized religion. As a teenager, I

visited several churches and dabbled in various forms of Christianity. When I was 17, I began working for a Pakistani Muslim family. As I learned about Islam, I decided that the beliefs made the most sense to me at the time. I was most attracted to Islam's overall message of unity and equality. I had grown up in the South during the 1980s. It was a very racially dichotomized space. A person was either "Black" or "White" and I could not fit into either of those categories. The Muslim community gave me a sense of belonging. I met my husband and married at the age of 19. By age 27, I was a mother to 5 children. My family regularly attended the mosque. Over the years I have sat in sisters' study circles and attended many workshops and lectures. I have organized playdates, volunteered for events, and served as a Girl Scout leader and Youth Group leader. I have listened to male imams discuss the high status of mothers in Islamic scripture as proof of how Islam favors women and I have also seen mothers break down weeping and lash out while citing overwhelming frustration and loneliness.[1] Over the years, it has occurred to me that the mothers' real life is never truly examined, but only discussed in relation to Islamic text.

Obviously, I am an insider to my research topic. Merton (1972) described an insider as one who holds intimate knowledge of a community and its members. Consequently, this position compels me to anticipate questions of bias. Biases, however, can be source of insight" (Aguilar, 1981, p. 26). An insider holds an understanding of the context and the background of the research topic. They do not have to orient themselves to the environment and can "blend into the situations without disrupting the social setting" (Greene, 2014, p. 4). Furthermore, qualitative researchers hold that all researchers come to their research with bias, but an insider may actually be more cognizant of their biases and may reach a deeper level of introspection about how their biases affect the research (Greene, 2014; Hendrix, 2002). In other words, I challenge that an insider is not more or less likely to hold any more biases than an outsider. This point is illustrated by Hendrix (2002) who wrote about her personal experiences of being asked "Did being Black introduce bias into your study?" She aptly points out that a White scholar would not be cautioned in the same way.

At the time of this project, I was 47 years old and a graduate student in Communication studies. My youngest child was 20 and my oldest was 27. My own experiences and identity as a Muslim woman informed the methodological decisions of this study. It was my own lived experiences that influenced my desire to capture the narratives of other women to articulate a perspective that has gone unheard. I specifically chose to do a qualitative project because I

wanted to make visible a problem that is rarely acknowledged or discussed. My experience is a practical orientation to better understand the experiences of other Muslim women's narratives of identity, their coping skills, and identity negotiation strategies.

Taking a Qualitative Approach

I chose a qualitative approach for this study because it was the best approach to accomplish the goals outlined in the first chapter. Qualitative methodology provides more in-depth detail (Creswell, 1998; Creswell & Creswell, 2018; Croucher, 2016; Denzin & Lincoln, 1994). In this approach, the researcher includes words, opinions, thoughts, emotions, and behaviors. A central tenant of this approach is recognizing that the researcher cannot truly be neutral or detached from their research (Clark & Jack, 1998). However, the qualitative researcher acknowledges and documents their biases. Furthermore, they consciously reflect on how these biases may affect the research.

As a qualitative researcher, I recognize what Denzin and Lincoln (1994) refers to as the "socially constructed nature of reality, the intimate relationship between the researcher and what is studied, and the situational constraints that shape inquiry" (p. 14). The data captured in a qualitative design extends beyond words to include attitudes, emotions, and nonverbal communication. This approach facilitates more meaningful exploration and grants a more holistic perspective of a social phenomenon.

I also base my decision to do a qualitative study on the eight reasons mentioned by Creswell (1998). The first reason involves the nature of my research questions which focus on the *how* and *what*. Second, a qualitative approach is most appropriate for a topic that needs to be explored. In other words, variables need to be identified and there are no existing theories that clearly explain the behavior of participants. Third, there is a need to present a detailed view of the researched topic. Fourth, there is a need to study individuals in a natural setting, rather than a clinical or unnatural setting. Fifth, a qualitative approach is desirable for a researcher who brings themselves into the study and writes from a subjective perspective, using the pronoun "I". Sixth, a qualitative approach is appropriate for a researcher willing to spend sufficient time and resources on data collection and analysis. Seventh, a qualitative approach is appropriate when audiences are receptive, meaning they view qualitative research as valid and credible. Finally, a qualitative approach

is desirable for a researcher who sees their role as an "active learner who can tell the story from the participants' view rather than as an 'expert' who passes judgment on participants" (Creswell, 1998, p. 18).

A Case Study

This project is an instrumental, exploratory case study. A case study means that I concentrated on a "case" or single "object of study,' and examined it in detail (Stake, 1995). The case or object of study is Muslim motherhood being explored through the narrative accounts of nine different Muslim women bounded by living and participating in the same religious community. It is exploratory because there is limited research on the lives of U.S. American Muslim mothers; thus, the general purpose of this study is to gain a basic understanding of my respondents' lived experiences of motherhood and mothering. I resonate with Simon's (2009) definition of the case study as an:

> In-depth exploration from multiple perspectives of the complexity and uniqueness of a particular project, policy, institution, program, or system in a 'real life' context. It is research-based, inclusive of different methods and is evidence-led. The primary purpose is to generate in-depth understanding of a specific topic to generate knowledge and/or inform policy development, professional practice and civil or community action (p. 21).

To be clear, a case study is not a method of analysis (Stake, 1995, 2005; Thomas, 2016). It is an in-depth and comprehensive focus on an object of study. Stake (2005) clarifies that a case study is not a methodological choice but a choice of what is to be studied by whatever methods are chosen.

Theoretical Framework

Hecht's Communication Theory of Identity (CTI)

This study focuses on the identity of a community of Muslim mothers. The concept of identity is traditionally associated with the discipline of psychology and is assumed to be located in the depths of one's inner psyche (Bergen & Braithwaite, 2009). However, scholars of Communication posit that identity is communication (Carbaugh, 1996; Hecht, 1993, 2004; Hecht, Jackson & Ribeau, 2003). Or more specifically identity is "located in social interaction through the process of communication" (Bergen & Braithwaite, 2009,

p. 166). Hecht, Jackson and Ribeau (2003) explain that "identity becomes a way of understanding constellations of behaviors that can be interpreted as creating, expressing, protecting, negotiating and changing identity" (p. 230). Put simply, identity is in everyday interaction or everyday talk (Duck, 1990). Our exterior communicative actions are not just manifestations of an inner identity, but they are an identity in and of itself. How we interact and communicate with others are not just mere expressions, but who we are.

I specifically used the Communication Theory of Identity (CTI) as the guiding theoretical framework (Hecht, 2004; Hecht, Jackson, & Ribeau, 2003). CTI is influenced by Social Identity theory (Tajfel & Turner, 1979) and is an expansion of the Cultural Theory of Identity or CIT (Collier, 1998; Collier & Thomas, 1998). (CTI) expands on Cultural Identity Theory (CIT) by recognizing identity as located in four layers (personal, enacted, relational, and communal) and forming through communication with other individuals. Jung and Hecht (2004) explain:

> The theory posits that social relations and roles are internalized by individuals as identities through communication. Individuals' identities, in turn, are acted out as social behavior through communication. Identity not only defines an individual but also reflects social roles and relations through communication. Moreover, social behavior is a function of identity through communication (p. 266).

A goal of CTI is to capture the complexity of identity by articulating a "layered perspective" that is conceptualized by a communicative performance or act rather than being the result/effect of communication (Hecht & Phillips, 2021). In other words, CTI recognizes that identity is complicated, fluid, unstable, and constantly negotiated. There are four layers (or frames) of identity: personal, relational, enacted, and communal.

Personal identity denotes how an individual defines themself. This is the identity that is most closely related to the interior world of the individual- or the self (Bergen & Braithwaite, 2009; Hecht, 2004; Hecht & Phillips, 2021). This personal identity is based on a conception that one has of their own values, and characteristics, and is expected to be somewhat consistent over time (Bergen & Braithwaite, 2009). This facet of identity is probably the most privileged in Western culture (Hecht & Phillips, 2021), and includes perceptions of the self -such as "tall", "funny", or "smart". At the same time, this frame will include group-based (or communal) identities based on ethnic/racial, religious, and gender identities (Tajfel & Turner, 1979). This identity is best captured in the respondents' explanations of the self.

The *enacted* layer of identity is the identity that is performed or expressed as we engage in social interactions with others (Hecht, 2004). Hecht (2004) clarifies that "enactments are not mere expressions of identity but are considered identity itself. That is, some aspects of communication are identity itself, and, at the same time, identity influences communication" (p. 266). In other words, communication itself is the locus of identity compared to the individual's interior thoughts or perceptions. Personal identity is how you see yourself, but the enacted identity refers to how you play the role of who you are. Related to this study, the enacted frame of identity can be related to how Muslim mothers present themselves or perform their identities in their communicative interactions. If one's personal identity is that of a "Muslim", then she may act as a "Muslim" – ascribing to the basic tenets such as prayer, fasting, charity, etc.

The *relational* identity is best understood by considering symbolic interaction's looking-glass self (Blumer, 1969). The looking-glass self describes the process where an individual comes to understand themselves based on how they believe others perceive them. It is a co-constructed and negotiated identity that emerges in relation to others (Hecht, Jackson, & Ribeau, 2003; Jung & Hecht, 2004). Relational identities exist in parent-child relationships, marital relationships, friendships, teacher-student relationships, and others. One perceives themselves a certain way based on how the other reacts to them. For example, a woman may perceive herself to be a "feminist" because she is told she is a "feminist", she is treated like a "feminist" etc.... The communicative interactions act as a type of "mirror" that individuals use to determine their own personal beliefs, judgments, and values.

The *communal identity* is the broadest and most overarching layer of identity. This layer articulates how society defines an identity (Hecht, 2004; Hecht & Phillips, 2021). This layer is defined through media representations, religious ideologies, politics, and education. Boylorn and Orbe (2020) further explain that communal identity is informed by collective memory, or rather, an ideology, which informs the construction of an identity. For example, Hecht and Phillips (2021) note that Western media has many examples of the characteristics which constitute a "good" mother. Good mothers are attentive to their children, take care of their house and bake cookies for the children's classrooms. Although this identity is located at the communal level, it informs all other layers of identity and manifests in the enacted, the relational, and the personal.

CTI also finds that while the layers of identity interpenetrate and function together, these parts can be inconsistent and contradictory. Jung and Hecht (2004) refer to the degree of such inconsistencies and contradictions as *identity gaps*. Hecht explains that identity gaps are "inevitable" (p. 268) as people are rarely perfectly transparent or consistent. Identity gaps can be positive or negative, cause stress and confusion, result in lower levels of communication satisfaction, and encourage feelings of being misunderstood (Hecht, Jackson, & Ribeau, 2003; Hecht, Warren, Jung et al., 2005; Faulkner & Hecht, 2011; Jung & Hecht, 2004). Orbe and Drummond (2009) describe a personal-enacted-relational identity gap that reflects a "discrepancy between how one sees himself or herself, the face one actually presents to others, and the identity supported within one's relationship" (p. 84). Jung and Hecht (2004) point out that discrepancies between personal and enacted identities are also explored in other communication theories including Goffman's (1959) dramaturgical concept of "front stage" and "backstage", and Petronio's (1991) Communication Boundary Management Theory, which holds there is "disclosed" and "undisclosed" parts of the self. Jung and Hecht (2004) explain that CTI differs significantly from previous theories due to its focus on intentionality. Goffman (1959) and Petronio (1991) are not concerned about identity but instead focus on impression management and individual privacy control.

Overall, CTI recognizes identity as "inherently communicative and social" (Jung & Hecht, 2004, p. 269). CTI forwards four interpenetrative frames of identity. By "interpenetrative", this means that the identities are related and cannot be separated. CTI also recognizes that there are bound to be inconsistencies between the frames or layers of identity. The degree of these inconsistencies is referred to as "identity gaps" and they are an inevitable part of human communication. Identity gaps cause anxiety and stress, create lower levels of communication satisfaction, and increase feelings of being misunderstood. (Hecht, Jackson, & Ribeau, 2003; Hecht, Warren, Jung et al., 2005; Jung & Hecht, 2004).

Guided by Van Dijk's Socio-cognitive Approach

CTI is the foundational theoretical framework of this study. However, when processing my analysis, I was guided by Van Dijk's (1995, 1998) "socio-cognitive approach" to critical discourse analysis (CDA). This approach considers the interrelationship between ideology and identity. Van Dijk's theoretical premise is that ideology is expressed through communication and embedded in

organizational and institutional contexts. Consequently, individuals develop their beliefs, attitudes, and value systems (identity) based on the influence of ideology. I find this approach to be the most useful as "Motherhood" is identified as an ideological construct (Buchanan, 2013; Kawash, 2011; O'Reilly, 2010). According to Van Dijk (1995, 1998), ideologies inform group identities, and group identities inform how an individual understands herself at the basest level. This approach guided my own understanding of how larger ideological discourses inform the social practices of a couple, or family, which, in turn, informs the subjective understanding of the self. Furthermore, this approach differs from traditional thematic analysis in that it does not assume neutrality but holds that discourse (or communication) is influenced by broader ideologies and reflects power relationships.

Research Context

This research study took place in a large metropolitan city located in the mid-southern region of the United States. According to the 2020 U.S. Census Bureau, the estimated total population is 633,104 with Black or African American composing 64.1 percent, Whites composing 25.7 percent, Hispanic or Latino composing 7.2 percent, Asians composing 1.7 percent, and two or more races composing 1.5 percent. The median household income is $41,228 and the poverty rate is 25.1 percent. It should be noted that there is no collected data on religion, thus the Muslim population remains unknown. However, as I explained in chapter one, the Muslim population is vastly diverse.

Case selection for this project was purposeful and based on predetermined criteria. I requested participants aged 25–45, married, and who identified as Muslim mothers. I also targeted my request to members of the same local mosque community. My own identity as an insider to this community means that I have a vast network of social connections that facilitate familiarity and trust. Thus, after gaining approval from the Institutional Review Board, I reached out to various contacts and sent an email with the request that it be forwarded to those possibly interested in participating. Initially, I intended to interview couples (both fathers and mothers). Due to the gendered dynamics of the Muslim community, it was more appropriate for me to direct my first email to married mothers, arrange an initial interview, and then read the cues of my participants to gauge whether it was appropriate to ask for an interview

with the husband.[2] However, in the first four interviews, women cited the impracticality of their husbands finding the time to participate in the study. Two of these four participants also expressed a desire to maintain the confidentiality of their participation *from* their husbands. One participant shared her opinion that women would speak more freely and openly if they perceived the project as a "women's only" endeavor. Based on their feedback, I adapted the goals of my study to focus solely on the perspectives of mothers.

I initially anticipated that I would have a difficult time finding participants due to three factors: the social dynamics of the Muslim community which emphasizes privacy; lack of trust due to the post 9/11 acts of government surveillance in various Muslim communities across the United States; and the social climate created by the COVID-19 pandemic.[3] However, I was able to find nine participants for this study. When it came to the question of race and ethnicity, I asked my participants to self-identify. One participant identifies as African American, two identify as White, four identify as South Asian, and two identify as Arab American.[4] Their ages range from 30 to 45. Two of the participants are new mothers of young children, two participants are mothers of school-age children, two participants are mothers of teens and young adults, and two mothers have children with ages ranging from school age to teens. All participants are college educated: five participants hold graduate degrees while four participants have earned their undergraduate degrees. One participant is currently in a master's degree program. I include more details about the participants in the next section.

The Mothers

This section comprises a list and description of the nine women I interviewed. In the interest of protecting the identity of my interviewees, I have omitted details such as specific professions and the gender of their children. I do include race and/or ethnicity, general educational and professional information, the number of children, and their age ranges:

Manar: Age 30, mother of one child. Describes herself as "Black" or "African American." Advanced education and professional career. At the time of our interview, she had taken a leave of absence.

Ameerah: Age 45, mother of four children ages 12–18. Describes herself as "South Asian" or "Pakistani". Advanced education and professional career.

Although she is accomplished and celebrated in her field, she is flexible about the time she devotes to her professional projects.

Rabia: Age 45, mother of three children ages 13–18. Like Ameerah, she also described herself as "South Asian" or "Pakistani." Advanced education and professional career. At the time of our interview, she expressed that she was "working on my own projects in my own time."

Mona: Age 44, mother of three children ages 12–18. She explained that she is "Arab American of Palestinian heritage". She has an advanced education and a full-time professional career. She was the only woman I interviewed who was working outside the home every day on an inflexible 8-hour schedule.

Hanan: Age 42, mother of three children ages 8–13. When asked how she racially or ethnically identifies, she stated: "I hate this question, but I guess I am white." At the time of our interview, she is pursuing graduate education and working part-time remotely.

Boran: Age 45, mother of three children ages 4–10. Boran describes herself as "Indian" before mentioning that she was not raised in India. Boran has a college education. At the time of our interview, she described herself as a "stay-at-home mom."

Zainab. Age 42, mother of one. She was born in the United States but notes that she is of South Asian or Pakistani heritage. She has an advanced education. At the time of our interview, she had recently left a professional career to stay home with her young child.

Lara. Age 41, mother of three children aged 5–10 years old. She describes herself as "White." She is college educated. I noted that while she described herself as a "stay-at-home mom," she mentioned working off and on in several part-time jobs throughout her marriage.

Nahla: Age 45, mother of five children ages 10–18. Like Mona, she is an "Arab American." She is college educated. At the time of our interview, she was working part-time and planning on going back to school to pursue a graduate education.

Overall, the respondents come from different cultural backgrounds with children of varying ages. This diversity reflects the overall diversity in the larger Muslim community. Another advantage is that the diversity in demographics allowed me to connect common themes found in the data to a shared identity as Muslim women, as opposed to another unifying characteristic such as possessing the same cultural background or having children of the same age.

Four interviews were conducted in person in the respondents' homes, and five interviews were conducted over Zoom (an audio-visual conferencing

software). The interviews averaged about 1–2 hours. I had some familiarity with all these women as we are members of the same mosque community. When I told Rabia that we could conduct the interview over Zoom she responded "Are you kidding? Please come over. I need a girls' day!". Nina, similarly, responded, "just come over. I wanted to get to know you anyway." Our shared identities as Muslims, mothers, and members of the same mosque community encouraged a sense of familiarity and sisterhood. This worked to my advantage by facilitating trust and openness. At the same time, I had to be especially careful not to let the conversation go off-track or provide any leading feedback. Interviews that took place over Zoom were slightly shorter than those conducted in person. On average, the virtual interviews lasted between 1 hour to 1 ½ hours. While in-person interviews were between 1 ½ and 2 hours.

I used an unstructured interview format for this project. An unstructured interview is more like a conversation than a formal interview. Thomas (2016) explains "…the idea really is for the interviewees to set the agenda. They should be the ones who determine the direction of the interview and the topics that emerge" (p. 189). Thomas (2016) suggests that unstructured interviews are better for case studies if you are trying to understand how your respondents behave in a natural environment. Semi-structured interviews may unintentionally lead to formality and rigidity in the research environment. Unstructured interviews are less intrusive and will facilitate a more conversational frame. Patton (2002) explained that unstructured interviews rely on questions that occur during the natural flow of a social interaction. Zhang and Wildemuth (2009) cite Denzin (1989) and Robertson and Boyle (1984) to explain that researchers who elect to use unstructured interviews believe that "to make sense of the study participant's world, researchers must approach it through the participant's own perspective and on the participants own terms" (p. 2). My choice of unstructured interviews is further supported by Barth's (2016) argument that this type of interview allows participants to compose their identities and tell their own stories. However, despite my intentions to allow the conversation to flow naturally, I approached each interview meeting with a list of questions, or "prompts" in the event the interview stalled. Throughout the interview process, I remained open-minded and allowed my respondents to guide the conversation and provide cues to follow-up lines of inquiry.

As mentioned earlier, my respondents were diverse. While this diversity allowed me to connect common themes found in the data to a shared identity

as Muslim women, I also ran the risk of sketching my respondents as a one-dimensional, monolithic group whose mothering identities are wholly ruled by "Islam". I was conscious of this tension when I elected an unstructured interview format. I chose it as a strategy that would prevent me from inadvertently collapsing my respondents' unique identities into a one-dimensional caricature of "Muslim mother." The intention was to allow my respondents to tell their own stories in their own words. Although I did have to refer to my backup questions at times to keep the interview on track, the unstructured format cultivated a free-flowing stream of conversation that allowed for spontaneity and openness.

I also kept extensive field notes. It is currently understood that field notes are a central component of rigorous qualitative research (Creswell, 2013; Phillipi & Lauderdale, 2017). My field notes contain both descriptive information and reflective information. Descriptive information is meant to capture rich details about the setting, facial expressions, vocal expressions, and other non-verbal cues. Reflective information captures the thoughts, questions, concerns, emotions, and reactions I experienced during the research process. I also included information about the setting. Both descriptive and reflective information is meant to contextualize the case and aid the researcher in constructing a thick description of the data. Field notes were both written and audio recorded to help contextualize the case and produce thick descriptions of the data. Maintaining field notes also allowed me to keep track of the progress of my study as it unfolded over time. I entered field notes immediately after the interview process but also added any relevant information as it became available to me.

Transcribing and Coding

In-person interviews were recorded on a small handheld recording device, and I used a smartphone recording app as a backup. Zoom interviews were recorded using Zoom's built-in recording feature. Although I used an unstructured interview process, I frequently referred to my interview guide and followed Creswell's (1998) direction to "be respectful and courteous and offer few questions and advice" (p. 125). Throughout the process, I took notes about the interview process and recorded my own thoughts and responses. Initial interviews took place over two months between June and July 2021.

Subsequent interviews took place in August and early September. After each meeting, interviews were transcribed.

Transcribing my own data prevented a gap in time for processing and allowed me to develop a close relationship with my data (Rubin & Rubin, 2012). I included hesitations, and laughter and noted any important facial expressions or gestures that were important to the data. Verbatim transcripts including nonverbal behavior are necessary to establish dependability, trustworthiness, and the highest level of accuracy (Easton et al., 2000). I also assigned pseudonyms and removed any identifying information from transcripts. All data was stored in a secure location on a personal computer that only I had access to. The next three chapters comprise a comprehensive description of the findings.

Notes

1 An imam is a person who leads the prayer in a Muslim Mosque. Since this is considered a leadership position, traditionally this role is exclusively assigned to men as based on the Qur'anic verse "Men are the protectors and maintainers of women." (4:34)
2 Traditional Islamic gender norms dictate that an unrelated man and woman cannot be alone together. However, Muslims, like members of other religions, have varying levels of faith and practice.
3 According to an analysis by the Costs of War Project at Brown University released this in September of 2021, about $1.1 billion of that has been spent on counterterrorism efforts in the U.S. including surveillance programs in U.S. American mosques and the loosening of longstanding law enforcement guidelines that made it easier to carry out intelligence investigations on citizens, often resulting in the profiling of Muslim Americans on the basis of religion or country of national origin in violation of protections provided by the constitution.
4 While four of my respondents identified as South Asian, they made a distinction about what part of South Asia they were specifically from. To protect identity, I am not revealing specific countries. One respondent stated that she would be considered South Asian but she is "East Indian by heritage."

· 4 ·

SCRIPTURE VS CULTURE

This chapter discusses the communal identity of the women in this study, as described by them in their own words. The communal layer of identity is the broadest and most overarching layer. It is comprised of categories such as gender, race, sexual preference, and religious and national identity (Hecht, 1993). In this study, the communal layer of identity was reflected in the respondents' identification with terms such as "woman," "mother," "Muslim," "American," "Southern," "Black," "White," "Arab American," "South Asian," "educated," and "privileged." Keeping with the goals of this project, I was focused on the ideological constructs of "Muslim," and "mother." Recognizing "Muslim," and "mother" as ideological constructs means that we associate these identities with certain characteristics, values, and attributes. I was interested in how these ideological constructs interrelate to influence how Muslim mothers understand themselves and experience life. I found two significant themes that resonated throughout every interview. Specifically, the women tended to repeatedly contrast two types of mothers: a mother esteemed in Islamic scripture and a mother "oppressed" by "culture." As I analyzed the data, I named these themes the "esteemed Muslim mom," and the "culturally oppressed mom." I also began to wonder if these descriptions reflect the dimensions of the same woman. Mothers are clearly held in high esteem in the imaginations

of Muslims, but it is less clear whether she is treated in the same high esteem by their children, husband, family, and community. It is also notable that all women connect high esteem to certain conditions or expectations of behavior.

The Esteemed Muslim Mom

All nine women proudly discussed texts, or what they believed to be texts, in Islamic scripture that discussed the high status of mothers. Specifically, all nine women repeated variations of the ubiquitous adage "Paradise is under the mother's feet." When pressed to explain the adage, there were various explanations. Almost all women immediately connected the adage to an expectation of the mother to be caring and sacrificial. For example, Hanan stated:

> Well, in Islam we say 'Paradise is under the feet of the mother.' When you think of a mother, you think of care. A mother is someone who cares the most. She cares for her children and her family. She loves them, she raises them. This is what God will ask her about. This is why in Islam the mother is three times more than the father-in terms of respect and love. She cares more and is loved and respected more. This shows you how important the mother is in Islam. This is why, in Islam, "Paradise is under the feet of the mother."

I asked Hanan to talk more about "caring". She initially posited that it was a quality that is "natural" in the mother, but then corrected herself and clarified that "being caring" is not necessarily a quality of being a "mother," but a "woman." She smiled broadly and stated: "It's how God made us."

Lara, a mother to three school-age children, connected the adage to a conception of the mother as a sacrificing figure. She said:

> Well. Um. We always hear that saying that heaven is under our feet and that mothers we have more rights than the father. We have three times as much. But when I think of a mother, the first thing that comes to mind is the sacrifice of a mother. And I think this is true whether you are a Muslim or a non-Muslim. Motherhood is [pause] sacrifice. But you don't know [pause] you can never know what all goes into it until you actually become a mother. And I think that is maybe what we're meant to do. We're meant to sacrifice.

As she talked, Lara began reflecting on her mother, a devoutly religious Christian woman. She stated:

> I don't see myself as doing anything different than my own mother. I think it's something that's true of all mothers no matter their religion. We sacrifice.

Like Hanan, Lara expressed the idea that there are certain traits and characteristics that are collectively possessed by certain identities. Women care. Mothers sacrifice.

In contrast, Nahla, a mother of five, did not initially discuss mothers as caring and sacrificial. She cited the oft-repeated adage but immediately connected it to an idea of mothers' power over their children. She said:

> When I think about being a Muslim and a mother the first thing that comes to mind is that 'paradise-or heaven- is under the feet of the mother'. This supposedly means the mother is the top. She's almost next to God in terms of respect and love. Three times more than the father. All prayers of the mother are accepted…. The last thing you want is to piss off your mother [laughs] because she can curse you!

Nahla further explained that she does not personally believe that God curses children due to the prayers of the mother, but she believes that other Muslims believe this. She said:

> I am not saying that I [emphasis] believe that God will curse you because your mother asks him to curse you, but a lot of people believe this. The mother is a powerful figure. Among Arabs, when the mother gets angry, she might say something in Arabic that means "May God burn you". [laughs] There is another one [pause] "May God show me the day that your life will be in ruins." [laughs] But for sure many women, specifically older women, abuse this power. They use such curses to control their adult children. Because the obligation to the mother never ends. You owe your mother until the day you die.

While Zainab, a mother of one young child, did not discuss mothers as having certain innate characteristics, she did emphasize the connection between the mother's high status and the obligations that women have toward their children. She told me:

> Okay, so we're talking about Islam and mothers? Well, the status of mothers is really high. Really, really high. There is a lot of respect for mothers. There is a lot of emphasis on motherhood. Mothers are mentioned before fathers in Islam. They are owed three times the respect. It's just because of the mother…carrying the child, breastfeeding the child, raising the child, you know? This is why. Because of everything the mother has to do. The child is the mother's primary obligation. Not the husband, not the house, but the child.

I asked Zainab about who, if not the mother, takes care of other matters in the household. She responded:

> Of course, the mother is going to do it if she is the one at home and the husband is the one who is working. Life has to have balance. Islam is about balance.

In every instance, the women referred to the well-known and oft-repeated adage about motherhood from Islamic scripture. Every woman had heard it. Notably, Manar expressed a skepticism about whether the popular adage was even true. She stated:

> Obviously, the first thing that stands out in my mind is that saying- that- I am not even sure if it is authentic or not- that saying that "paradise is under the feet of the mother." I don't know if that's a real saying or not. Do you? It's just something that I have always heard.

I responded that it was indeed authentic and asked Manar if she could recall where she had "heard" it before. She thought for a moment and said:

> I am not sure! I have just always known it. Maybe from Islamic classes, maybe from my mom, but I am not sure. I think it's more like from songs and stuff while I was growing up. It's something mentioned in passing. More recently I see it on the internet in memes.

In further conversation, Manar shared that she believed that God included this direction in the Qur'an to "help the mom feel better" about "everything she has to go through" in relation to childbirth and parenting.

Culturally Oppressed Mom

For several women, conversations about the high status and esteem afforded to mothers were coupled with conversations about the cultural influences on motherhood. Specifically, seven participants described a distinction between "Islam" and "culture." When following this line of inquiry my participants raised their voices, spoke passionately, and expressed more emotion. As a Muslim woman myself, I sensed a need to rescue Islam from its negative stereotypes; particularly stereotypes surrounding women and mothers. The effort to distinguish Islam from culture is exemplified in excerpts from the following conversations with Rabia, Ameerah, and Zara.

As soon as we began the interview, she made the following disclaimer:

> I should tell you that I grew up a cultural Muslim. We did not learn Qur'an or Hadith or anything like that. My parents raised us culturally as Muslim, but that was it. We did not pray, or practice. My parents raised us that boys do whatever they want. They had no responsibilities, whereas girls did everything. Girls did all of the cooking, all of the chores, and they could not leave the house. This was cultural. This had nothing to do with Islam.

Rabia further explained that as she has become a mother herself, she strives to practice a more "authentic" and truer form of Islam. She said:

> As I study Islam, I understand it to be charitable deeds. I am not raising my boys like how I was raised. My boys have chores, they learn to cook, they have responsibilities…. I want them to be good men. And whether they like it or not they are examples. I am just really trying to raise my boys to be that renaissance guy who can go into the kitchen and do everything.

Twice in the interview, Rabia expressed the sentiment that she may not be the "best example of a Muslim" because she was still "learning the difference between Islam and culture." She described her own mother as being a "cultural Muslim woman" who "did everything for her family" to the extent that she was "essentially a slave". Rabia told me that her own marriage was arranged after she finished her bachelor's degree. Her husband was in graduate school at the time. Rabia said that during their initial phone conversation he told her "Hey if you want to have a career you can. I want my wife to have a career." She described being incredibly relieved after that first phone conversation. Although he was raised in a similar family as Rabia's, he wanted to do things differently. Shortly after marriage, she applied for graduate school with his "blessing and support."

Ameerah also spoke negatively about what she named as "culture." Like Rabia, Ameerah described herself as "South Asian or Pakistani." The mother of four became particularly animated as she discussed the high status that mothers "supposedly" have in In Islam. She immediately connected this status to what she described as negative cultural expectations. She widened her eyes and gestured as she stated:

> Mothers supposedly have a high status. Heaven is under her feet, they say. But in my culture at least-you take parts of the religion, and you twist them, and you twist them, and you twist them, and you make them adapt to your culture [pause] and it morphs into this status that is so high, so high… you can't bring it down. But to earn that status of being a mom, a good mom, a woman basically must sacrifice her entire self for the family. She is not allowed to be her own person or have agency to herself

and that's when she gets that "worship her" status, when she gets that status to be on a mantle. [raises voice] But to be on that mantle she has to be a doormat first. Mom has no needs. She's not a person. She's just there to serve you.

Ameerah described her own upbringing as "cultural" and added, "culture is toxic". Like Rabia, Ameerah declined to share extensive details about her own mother but said that she "did everything for the family and "basically wasn't a person." Ameerah shared that she "didn't want to be like that" and that her own children were fully aware that "Mom has needs too."

Zara also made a distinction between culture and Islam, however, unlike Ameerah and Rabia, she acknowledged that she performed motherhood more in line with the cultural concepted mother. She said:

> Often the way we practice mothering is imbalanced. This comes from culture. In Islam, there is a balance. Islam has clearly defined roles for men and women. They're separate but equal. They're different. They're not the same. But that doesn't make one more or less important than the other. That is something that is very important for me to point out. Islam is balanced with the roles for men and women. Sometimes I feel like there is an imbalance, but that's culture. When you see a mother doing 90 percent of the childcare and housekeeping, you have to think about it [pause] ask yourself is that Islam or is that culture? It's culture!

I probed Zara about the "we" in her statement, "Often the way we practice motherhood is imbalanced." She took a breath and responded "Me. The way I practice motherhood is imbalanced. But that's my culture. Not Islam." I inferred that although Zara was born in the United States, she was referring to ethnic or cultural practices she learned from her parents.

Notably, there were two participants who discussed "cultural" influences on how Muslim motherhood is practiced and understood in Muslim communities in the United States. Specifically, Manar was intent to clarify there is a difference between Islam and culture. As her one-year-old daughter shifted restlessly in her arms, Manar noted:

> One thing that always stuck with me is that as a woman, specifically as a mother in Islam, is that our main duty is raise our children, but not necessarily [pause] we're not required to do housework. We are not required to do anything else but take care of our children. We're not required to cook or do any stuff like that. This has always stood out to me because culturally culturally, they have made it that if you are a housewife or a mom that cooking, housework, and all that falls under your duty.

I noted that Manar was the only participant who described herself as "African American or Black" yet had repeated the word "culturally" twice when describing influences on motherhood. Knowing that her own mother was a U.S. American I asked her to expand on what she said about culture and to clarify who the "they" was. She raised her voice to drown out her daughter's cooing and answered:

> Foreign Muslims! [emphasis] I think in our community it is the strong presence of these foreign-born Muslims from these eastern countries. Arabic-speaking countries. Hindi-speaking countries. Urdu-speaking countries. East African countries. They have these more paternalistic societies in their home countries and it kind of perpetuates and infiltrates American Muslim society, *but* on the flip side [emphasis] Black Muslims [pause] um I don't know too much about White American Muslims but um Black Muslims or Black communities overall have a strong maternal presence [pause] like a grandmother and moms have more say in how a family is run, but in like in an Eastern country [pause] in their culture the man has the final say.

Manar was not the only respondent who cited the presence of "foreign-born" Muslims in U.S. America as creating a negative conception of motherhood. Hanan also noted a difference between "European cultures" and "traditional" cultures. She stated:

> A lot of the women running the Islamic study groups or classes are from very traditional cultures like Saudi Arabia, India [pause] they're from very traditional cultures. So, they mix their traditional cultures with Islam, and they have a big influence on how we understand ourselves as women and mothers. For them, the woman is for the house, for the children, for the husband. A lot of burdens are placed on the mother, but this is from tradition.

Other participants used terms such as "immigrants" "back home mothers" or "village women" in derogatory ways while describing cultural influences on Islamic conceptions of womanhood or mothering. For example, when discussing the early years of becoming a mother, Nahla described going to the mosque and being influenced by "grouchy immigrant" women who were "bitter and oppressed by their husbands." Nahla explained that many of these women could not speak English, did not work, and only left the house to attend religious events at the mosque. Nahla said:

> I used to try and socialize with these women but some of them are child abusers. I was in a home once where a baby, maybe 18 months old, had already learned not to touch anything. There was a lot of décor on shelves and the table and the baby was

not touching it. The mom was really proud of this. I think he accidentally touched something and the mom immediately slapped him in the face screaming at him "LA," which means "no" in Arabic. I told her 'what are you doing?' But she was really proud of her parenting, and she was really proud of her house.

Nahla and I went on to discuss the tremendous pressure these women are under to keep an immaculate house while raising their children. We speculated that it might be partly a "cultural" expectation and partly an expectation that women put on themselves. As Nahla stated

> Women do this to other women. Mothers-in-law do it to their daughters-in-law. Sisters-in-law do it. Friends do it to other friends. They judge each other, they shame, and they backbite. Women themselves have the power to stop it and change the culture.

The above excerpt is an example of how the line between "esteemed Muslim mom" and "culturally oppressed mom" becomes muddy when expectations and obligations are placed upon the mother. Perhaps the connection between these two mothers is best conceptualized by Ameerah when she described the mother as holding a "'worship her'" status that places her "on the mantle" but claimed, "to be on that mantle she has to be a doormat first".

In summary, the women I interviewed tended to describe Islamic scripture as holding mothers in a high status but always attached that high status to certain conditions or expectations. The next chapter focuses on the relational and enacted layers of identity, granting a closer examination of those conditions and expectations. Notably, Muslim women are also invested in defending Islam, responding to caricatures of themselves, and calling out any mistreatment, oppression, or injustice that women face as due to "culture." As a Muslim woman myself, I am aware that we are often tasked with fighting two fronts: we must defend ourselves and our religion from outsiders while also battling injustices within our own community. It is an overwhelming endeavor that may distract us from assessing our own needs.

· 5 ·

MOTHERS' OBLIGATIONS AND FATHERS' ROLES

This chapter explores the relational and enacted layers of identity described in the interview data. The relational layer is defined as a co-constructed and negotiated identity that emerges within an individual's relationship with others (Hecht 1993; Jung & Hecht, 2004). For the purposes of this specific project, the relational layer reflects what participants described when discussing their relationships with their husbands and children. The enacted layer is the identity that is performed or expressed as the individual engages in social interactions with others (Hecht, 2004). This dimension of identity is best captured in the most salient ways participants discussed performing (or communicating) motherhood. Due to the interpenetration of layers, every way that mothers perform or enact motherhood coheres to their relational identity. In other words, motherhood will always be performed or communicated based on the relationship the mother has with her children and husband.

Child Rights and Mother's Obligations

When discussing their relationships with their husband and children, all nine participants discussed the high status of mothers as directly connected to their obligations toward their children and family. I noted that the participants were

mostly inclined to discuss these relationships in terms of "rights" and obligations. I found this was the case whether the woman stayed home with her children or worked part-time or full-time outside the home. All the women interviewed explicitly stated that mothers have "obligations" and some noted that children have "rights." For example, Manar mentioned the "right" of the child to breastfeed. Referring to her studies of Islamic scripture, she noted:

> I was reading about breastfeeding, and I found out that babies have a right over the mom for breastfeeding for two years. I mean [raises voice] I heard that it was recommended for two years but I never knew that it raised to the level that it is of like *a* [emphasis] right. It's a right of the child. I mean, it's someone so small who isn't even talking, and they actually have rights over you!

Nahla also mentioned breastfeeding as she explained how she perceives her practices of "attachment parent" as aligning with certain rights children have over the mother. She asked if I was familiar with attachment parenting. I responded, "a little, but explain it." She answered:

> So I practice attachment parenting. Attachment parenting recognizes that children should have their needs met, and when those needs are met, the child grows to be a more secure person. We don't believe that it's possible to spoil a child or to let them cry it out. When they need to be fed, you feed them. When they need to be held, you hold them. You love them, you care for them. They have rights over the mother. Like, I co-slept with my babies when they were breastfeeding. It made it easier. And this aligns with Islam as babies have that right, that right to breastfeed. They have the right to the antibodies, and to nutrition. And science backs up how important it is for babies to breastfeed. And this is one of the fundamental rights of the baby: to receive proper nutrition and protective antibodies. I mean, that's kind of amazing if you think about it. It's amazing that Islam recognizes that.

For both participants, the right for the child to breastfeed is understood from traditional Islamic discourse.

While other mothers did not specifically mention breastfeeding, most were adamant about mothers having obligations toward their children. Ameerah raised her voice and spoke passionately as she stated:

> Mothers don't have the right to demand their children respect them just because they are a mother. For me [raises voice] I don't ask my children to respect me. I don't repeat the hadiths. I don't use religion that way. As mothers, you must lead by example and do your obligations first. For example, if your environment is toxic, and you're toxic then you can't expect your children to respect you. Me personally, I don't expect my

children to behave in any certain way. If they misbehave, then that's on me. I am held accountable for that. It's my responsibility to teach them how to behave!

Ameerah was directly challenging the idea that mothers are owed respect solely due to biology. For Ameerah, the identity of the mother is connected to her duties to properly teach and educate her children. Ameerah went on to explain that she "didn't even like children," but as a mother and a Muslim she saw it as her responsibility to ensure that her children were "successful, happy, and well-behaved." It may also be important to note that Ameerah is one of two mothers who employ a housekeeper. Thus, for Ameerah, the duty of the mother is restricted to teaching and caring for the children. They do not include cooking or housework. Full-time working Mona also framed her discussion of motherhood around obligations and responsibilities. She explained:

> A mom is the one responsible for pretty much everything that has to do with the kids. Their education, their spirituality, and their safety. Moms make sure they pray, make sure they're studying, they're clean, and they aren't watching inappropriate shows on TV. All those obligations are on the mother.

I asked Mona to clarify "who" puts such obligations on the mother. She paused thoughtfully before continuing:

> I am saying how it is supposed to be. I am discussing an ideal. Not every mom is successful. In fact, most of us aren't. I'm certainly not. But we are obligated to try. We have to aim for the ideal."

Notably, Mona is a mother who never put her professional life on hold for her children. She had previously explained to me that she has consistently worked full-time for the entirety of her marriage. Mona does not see herself as "obligated" to financially provide, however, as she also explained, "what should be and what actually happens are not the same thing." In other words, the reality of her life situation means that Mona must work and be an "equal breadwinner." Yet, despite, working full-time, Mona sees herself as fully responsible for every aspect of her children's lives.

While Hanan does not work full-time, she does work remotely for "three hours a day" while currently enrolled in a graduate program. Despite having a very full personal and professional schedule she expressed a similar sentiment to Mona's when she noted:

> As a mother, you have rights on your children and your children have rights on you. Mothers' rights is for children to listen to them and to respect them. But children's rights are for mothers to take care of them and teach them. Mother has to do her part so children will do their part. Mothers have to do a lot [laughs]. Maybe we do too much. [laughs].

During other parts of the interview, Hanan expressed her feeling that motherhood could be "overwhelming" and when tasked with several obligations at once, it is up to the mother to "figure it out." Another mother I interviewed, Boran, does not work outside the home. However, Boran's interview highlights how stay-at-home mothers' lives are heavily burdened by different responsibilities. When I visited Boran she was struggling to entertain her younger daughter while fielding calls from school officials and making medical appointments.

> I was thinking about the subject of this interview, and I want to tell you something. The mother is a woman who is obligated to her children. Obligated for everything. Like when my son [name redacted] was being diagnosed with [redacted] it's my responsibility to handle this with the teachers, and doctors, and his specialist. It's not on my husband, it's on me. I was thinking about this while I was waiting for you. It's not just a Muslim issue, but also a social issue. Everyone sees the mother as having the obligation for any issue that is related to her child. This is not just a Muslim issue. It's a social issue.

Boran seemed particularly concerned about caricaturing Islam or Muslim women. She repeated the sentiment "this is not a Muslim issue, but a social issue" two times in our conversation. The second time she mentioned it, I made a note in my journal. When she saw me writing she said "yes, write it down. Write down it's a social issue, not a Muslim issue." I looked up from the journal and agreed with Boran. I said "Yes, you're right" and shared my opinion that the obligations of the mother transcend religion and culture.

Lives on Hold

In many of the interviews, the discussion of rights and obligations became intertwined with a discussion of the women's own personal and professional goals. Women repeatedly mentioned how they had left schools and careers to focus on their children and family. For example, Boran explained that recently she felt the desire to return to school and get an advanced degree, but she didn't believe it was immediately possible. Having earned her bachelor's

degree in English, she confessed that she was unsure of what she wanted to study. She explained:

> So I got married at twenty-one and my husband and I both finished our university together. And so through that time, I was working until I got pregnant. When I was pregnant, we pretty much decided that I was going to stay at home because I could not see myself putting a three-month-old baby in daycare. Since then, I want to go back to school but at the same time, I cannot see myself having the time to study. There are just too many obligations and they're not going away.

Boran also confessed that she was concerned about her son's health and what it would mean for his future care. She shrugged and said, "It will be never-ending." Boran's circumstances suggest that she does not have any control over whether she can return to school.

Other mothers I interviewed clarified they decided to stay home with their children of their own free will. For example, Nahla clarified:

> I married young and had my children young and it was just understood that I would not work. Why would I? How could I? I tried to get my master's degree a few years ago. I enrolled in one of those online for-profit colleges before I realized that my degree wouldn't be worth anything, so I dropped out. I didn't really have time to go to school locally on campus, so I got duped by an online program. But I am going to enroll full-time now that my children are older. I am just not sure what I want to study. But now I finally have the chance.

Nahla expressed that it was simply impossible to work as a mother to young children. She really "did not have time." Now that her children are older, her circumstances have changed. Lara's children are still young. She explained:

> After I finished my undergraduate, we decided that I would stay home because we wanted to have children at a young age. That was my decision. When the girls get older, I would like to continue my education but right now my primary job is raising them.

While Boran, Nahla, and Lara finished their bachelor's degrees before deciding to stay home, Rabia was able to finish law school. She told me:

> So I took the bar exam a year after graduating from law school, soon after expecting my second child. And this was difficult. I was very committed to working but based on my husband's job and his crazy hours I realized that even though I had taken the bar exam and I wanted to practice the law, I made the decision to stay home and prioritize my children, knowing that I would not have any support from him. I knew

> I would do it alone. But that was my choice because as the mother I am obligated to put my children first and take care of their needs first.

Rabia continued to explain that her husband would "have never been ok" with her going to work or practicing law while the children were young. She said, "If I had done that, he would have quit and stayed home with the kids." I asked her whether her husband quitting work to be a stay-at-home dad would have ever been a real possibility. She laughed and said "Of course not. Because I would not have ever really left them to daycare or babysitters. I am just explaining how strong his principles are." Rabia, like many of the mothers I talked to, emphasized that caring for their children is their priority. They made conscious and purposeful decisions to put careers and education on hold to devote themselves to caring for their children.

Fathers Are Providers

With the women I talked to, there is an overwhelming consensus that the father's role is to financially provide for one's family and children. This point is further exemplified in the following excerpt from the interview with Nahla.

> I work because I want to work. And I want to have 'extras' in my life. But I do not have to. Islam recognizes that women are made vulnerable through biological circumstances. A woman gets pregnant and breastfeeds. This will bind her to the home, at least during certain parts of her life. So she is not obligated to go out and work. She can, but that's not her job. That's not her obligation. There is comfort in knowing that is not your obligation. There is comfort in knowing that's not your problem.

Nahla, as the mother, describes being comforted in knowing that the financial burdens of her large family are not her "problem." I responded by asking "so it's your husband's problem? The man's problem?" She clarified "Well, I would not say it is his 'problem,' but it is his obligation. But I do work to help. Because today one person cannot do it on their own."

Nahla, like many participants, tended to initially discuss the man's role as outlined in Islamic scripture before discussing the reality of their own lived situation. Nahla works to supplement her husband's income. Although she describes being "comforted' by knowing the financial burdens of the family are not her "problem," she addresses this "problem" by working. Perhaps the contradictions between the ideal role and the lived experience are best explained by Mona, who described herself as an "equal breadwinner." She stated:

> The man is the protector and the provider. The mom is the nurturer. The mom is the one who loves. The one who gives everyone hugs while the man is standing there and making sure everyone is safe, protected, and has everything they need. It's his responsibility to lead the family, protect the family, and create stability for the family.

But then clarified:

> "I am discussing an ideal. I am being theoretical. What should be and what happens is not always the same"

Mona, like many of the other women, tended to use caricature descriptors such as "provider," "protector," and "breadwinner," when discussing the relational identity of the father to the family.

Lara suggested that the father's responsibilities transcend the mother's responsibilities. In other words, he has a more crucial role. She explained:

> Fathers are the backbone of the family. He is the provider. The protector. The breadwinner. But he is also an example for the family. I know a lot of things get pushed on the mother, but the father has almost a bigger responsibility in the family. The father is supposed to be the example- the example of how to really be a good Muslim while also providing. That's a lot.

When I attempted to probe participants for more information about how fatherhood looked in their day-to-day lives, there was a myriad of descriptions. Seven out of nine mothers described their husbands as having limited interactions with their children, often citing their husbands' "long hours" and "work schedule." This is exemplified in the following statement by Manar. When asked about what (if any) responsibilities her husband has toward their small child, she explained:

> He has a crazy schedule, so he is barely at home. When he is at home, he tries to do all the stuff that I do with the exception of bathing and feeding. Because of his work schedule, he misses out on a lot of things.

At the time of this interview, Manar was one of two mothers who had only one child. The other was Zainab. In both cases, the children were under the age of two. Zainab described a similar situation as Manar. However, one significant difference is that Manar's husband was described as "barely at home" while Zainab's husband worked remotely. Explaining that he spent most of his day behind a closed door she said, "just because he's home doesn't mean he is

not working. Just because he is here doesn't mean he is here [emphasis]" She explained:

> Of course, I want him to do more. I want him to be more involved. But every mother is going to say that. Every mother wishes her husband would be more involved. Sometimes I am frustrated, but I remind myself that he works hard to provide for us and I am grateful for that. I consider us lucky to have him.

Like Zainab, Rabia spoke positively about her husband's limited time with their sons. Citing his demanding schedule and long work hours, she explained:

> My husband is not able to always be physically present with the boys, but he is still a parent when he can be. Recently, he has made a point to be there for the boys' games. He wants to be there for them in the background cheering them on. That was important to him. But recently the boys objected to that. They let him know that instead of taking time off to be at their games, they would rather spend that time with him.

When asked to clarify what the boys wanted from their father, Rabia elaborated:

> You know [pause], watching a movie, getting ice cream [pause] instead of him being in the background watching them play their games they would rather use that time to talk and interact.

I asked Rabia if anything had changed yet. She laughed and said "not yet" but continued to speak positively of the limited interactions her husband shared with her sons. She stated:

> Growing up, the role of the father was discipline. The father did not get involved with the children until it is time to discipline them. But from my perspective now, in my own family, the role of the father is not so much discipline as it is stability and security. The father can make the home and the family feel secure or insecure. My husband has this ability to validate the child, or make the child feel secure because he has such limited time with the child. Dad can be there to check in to make them feel like "you're doing a good job, you're on the right path," as opposed to me, who is more involved with them, and knows everything that is going on, so I might question everything they do. I might be like "why are you doing this?" Or "why is it this way." I might not have the same degree of positivity that their dad has.

Rabia continued to express understanding of her husband's minimal presence in their children's lives. She explained that she had long ago accepted that it comes with his career.

Fathers as Religious Examples

Aside from describing fathers as "providers," the women also noted the responsibility of the father to be a religious example. Manar, for example, described a husband who worked long hours with a "crazy schedule," but also explained that he regularly takes off for Friday prayer. At the time of the interview, we were still under COVID-19 restrictions which meant many mosques and other houses of religious worship were closed to the public. Manar explained that her husband "could not wait" until the restrictions were lifted, and he could start taking their daughter with him to religious services.

Both Nahla and Hanan described their husbands as leading their family in congregational prayers in the house. Hanan explained that this was something her family had started doing when the mosque closed during the COVID-19 quarantine. She said:

> But one thing I am happy about is that we started praying in the house since COVID-19 when they first closed the mosque. My husband started leading the prayers and he is teaching my sons to lead the prayers. Sometimes my husband leads, and sometimes my sons lead, but no matter [pause] they have to wait for their father before they start the prayer so he can be there to correct them if they make a mistake.

She continued to explain:

> Before this everyone in the family used to pray on their own. You say 'go pray, go pray'. I personally don't really like this idea- the mother telling her child to 'go pray' when she is just sitting there!

Lara, Ameerah, and Boran described husbands who read Islamic stories to their children and teach them Arabic, or other religious studies. Lara, who homeschools her children, explained that Islamic studies are the one and only part of her daughters' education that her husband is responsible for. She said:

> So, I am just not good at remembering the stories of the Prophets, or knowing a lot of hadiths, so that's his responsibility. He sits with them sometimes and he gives them Islamic studies lessons. I am responsible for teaching them correct Islamic behavior and whatnot, but he does the other stuff...

Ameerah similarly noted:

> My husband handles all the religious education of our children. He teaches them the Quran, the hadiths... He is the knowledgeable one about the religion. He handles all of that.

Mona differs from other participants in acknowledging that although ideally the husband is supposed to be responsible for the religious upbringing of the children, that does not always happen. Repeatedly throughout the interview, Mona contrasted her own family dynamic against the "ideal." For example, she explained.

> The man should be responsible for leading the family in prayer but what should be and what actually happens are not the same thing. I am speaking theoretically. What happens in my family is different than what should be. My husband is supposed to be responsible for the religious upbringing of the children, but quite frankly he does not do that. I do it. And to be honest, he would probably prefer if they didn't learn about religion at all, because he's not religious. I do think it is interesting that Muslim women are required to marry Muslim men...that's all that matters. It doesn't matter the degree of "Muslim-ness" that a man has just as long as he checks off this box [pause]. And yet – he's responsible for being the religious leader of the family!

In sum, seven out of nine women interviewed described the role of the father as a religious example. Participants describe husbands who fulfill this identity to varying degrees. Some fathers lead prayers, and others teach their children Qur'an or tell them prophet stories. In Mona's case, the reality is different from the ideal, as her husband does not take on this role.

Fathers as Partners and Co-parents

Out of the nine mothers I interviewed, three mothers described husbands who, although saw themselves as "providers," were also very involved with their children. For example, Ameerah told me:

> My husband is completely involved with the kids. He knows what's going on with them- probably more than I do. Like recently when my daughter got her period, she called her dad. Not me. Yes, he earns money, but then he comes home, and he takes care of his kids. And we both have responsibilities outside of the house too. This is a shared partnership.

Ameerah went on to explain that her husband has taken the responsibility to drive their children back and forth to their activities because he is "closer" to the children than she is. She also says that it is more practical for him to

perform basic family tasks like grocery shopping since it is on his way home from work. She raised her voice to a higher pitch when she explained:

> My friends laugh at me because I have never been inside a Trader Joes. You will never see me inside of a grocery store. Maybe I will go into Fresh Market, but only if like, for example, I forgot the cupcakes for my daughter's class or something. Otherwise, my husband does that. Why should I do it?

Nahla similarly explained that although her husband was always the primary financial provider for the family, he is also responsible for completing a myriad of other tasks. She took a sip of tea right as she stated:

> If my car needs gas, then he will take it and put gas in it. If one of the kids need a computer, he does the research and figures out what is the best deal and the best warranty. He does the bulk of the grocery shopping. I do the little shopping, but when it comes to the bulk shopping like our staple food then he does that.

Nahla also noted that her husband is better at nurturing the children. She said:

> If I am honest then I must admit that he has always been a better father than I was a mother. He's always been 100 % involved. I have a selfish streak. He is the one who walked the floors with them at night when they were sick. He ran them to emergency rooms because I couldn't handle the stress of… [laughs] whatever happened that required them to go to the emergency room. He takes them to their classes and play dates. But, in my defense, we have five children.

At this point, we both laughed acknowledging that mothering five children was something that we had in common. "You know how it is" Nahla grinned. I responded with "Yes I do!"

Like Ameerah and Nahla, Boran also explained that while her husband sees the family as his "financial responsibility," he also regularly participates in childrearing. However, this is not a dimension of his fatherhood that he publicly shows. Boran explained:

> We come from a culture where a guy is not really expected to participate in childrearing. The man's job is come home, put his feet up and be served. He doesn't serve… and you know, my husband is really great… he does help with the kids, and he changes diapers, but he told me- "Do not ask me in front of people to change the kids' diapers. I will do it as much as you want in the house when it's just you and me but do not ask me in front of people!"

Nahla also alluded to shame experienced by fathers who take an active public role in childrearing. She said:

> When people would visit us, or see us at the masjid, or even his own family members- people would say that they "felt sorry" for my husband. They felt sorry for him if he was wearing a baby in a sling or if he was just basically taking care of his own children. His mother said she felt sorry for him. It was a big scandal in the family for a while. They say my husband is 'whipped' or that I am doing 'witchcraft' on him to control him. Why? Because he takes care of his own kids? It's very ridiculous.

In sum, these three participants described fathers actively involved in parenting their children. Ameerah and Nahla describe fathers who are fully involved in both public and private. Boran described a husband reluctant to reveal that dimension of his personality in public. Both Boran and Nahla acknowledge that there is shame and stigma surrounding men who are actively involved with their children.

Performing Motherhood

As part of accomplishing the goals of this project, I sought to capture the enacted layer of identity. The enacted layer is the identity that is performed or expressed as the individual engages in social interactions with others (Hecht, 2004). This dimension of identity is best captured in the most salient ways my participants discussed performing or communicating their motherhood identity to others. Due to the interpenetration of layers, every way that participants describe "enacting," or performing their mothering identities cohered to their relational identity. In other words, participants describe interactions with their children and husbands that are dictated by their relationships. Furthermore, relational identities are intrinsically informed by the beliefs and value systems of the communal identity. To isolate the enacted layer of identity as much as possible, I asked my participants to discuss their everyday lives. Due to the topic of our interview, it is unsurprising that all nine participants described activities that centered on meeting the needs of their children or households.

For example, when Zainab explains her day-to-day activities, she describes performing her mothering duties in support of her husband's role as financial provider. She said:

> My day-to-day life? Childcare? That's on me. Feeding? That's on me. Bath time? That's on me. But it's really because he is working and even though he's here, he's not here. I can't expect him to drop what he's doing and involve himself. Especially since I am not working. Ninety percent of responsibilities fall on me. And every day is a struggle.

Zainab then clarified that the reason "every day is a struggle" is due to her own choices. She said:

> But I also do that to myself. I am a task-oriented person, so I feel that some of that is me, my own personality, and my own expectations of myself. I do feel like maybe I do put so much pressure on myself to do everything and be everything. I stress and get anxious. Like for example, If I can't get dinner because my son was having a particular clingy day and we have to get pizza, I feel like that's on me. I feel like that is my responsibility and I failed. I feel anxious and I feel frustrated, and I have to tell myself that tomorrow is another day and another chance to get it right.

When describing her interactions with her child, Zainab explains:

> Well, today he is with his grandparents, but if he is here then he is always with me. Whatever, he is doing, I am with him. If he is coloring, I am coloring with him. If he is playing with his cars, he's right here next to me. If he was here right now then he would be in my lap saying 'no phone, no phone, no phone?' [laughs]. He'd be looking at you in the camera and saying, 'who that?' [laughs]. He's very clingy, but it's also just because he prefers me.

Like Zainab, Lara described day-to-day activities centered on domestic duties in the household. As a mother to three girls, Lara explained how she wakes in the morning to prepare breakfast and get her daughters ready for the day:

> I get up 8 or 8:30 and make breakfast. Clean up. Get them dressed. I am homeschooling them so there are lessons that we do at the kitchen table. Then I make lunch. Clean up. Make dinner. [laughs]. I guess I am just always in the kitchen! They keep me in the kitchen…! [laughs]. No, I'm just kidding, but I suppose our days can be stressful. Motherhood is a blessing, but it is also a hardship. There are some days I do wish my husband would take the kids and just leave me alone to clean the house in peace.

Lara also explained that after caring for her children throughout the day, she worked for 10 months in the evenings as a supermarket cashier. She said that she only went back to work in order to afford to send one of her daughters to a summer camp for "young engineers." I asked her if the duties in the house

changed or stayed the same while she was working. She smiled warmly and sighed, "they stayed the same."

Lara continued to explain that when she gets a chance, she spends time reading books and researching "gentle parenting" techniques on the internet. The concept of "gentle parenting" informed her interactions with her children. She explained:

> Gentle parenting means you talk to your child instead of immediately punishing them. You show them understanding, empathy, and encouragement. You don't raise your voice or treat them harshly. When your child does something wrong, you work with them to figure out 'ok, why did I do this?' 'What were my motivations?' 'What can I do better next time?'

I asked Lara about her husband's style of parenting and about whether he practiced the same style. She answered:

> No not really. I think he wants to see me try something out first and see how it works. But… [long pause] I also think he probably just feels more confident in what he's doing. Whereas I am not so sure. So, when I parent my daughters or try to teach them something, I am gentler and more forgiving with them.

Like Zainab and Lara, Hanan described day-to-day activities that focused on domestic duties. However, Hanan mentioned the added task of driving their children back and forth to different activities. She stated:

> When it comes to waking them up in the morning and getting them ready for school, it's mostly me. Getting breakfast or packing lunches – me. Dropping off and picking up- mostly me. Currently, I am working from home for like three hours a day, but my schedule is adjusted to be a mother first. And yes, it is sometimes really stressful.

She continued:

> Ok, like I worked like three hours today. For example, both of my kids have summer camps. So I have to get up and drop this one of and the other one off and work three hours and then go back and get them and tomorrow is more crazy because my daughter has a volleyball practice. I asked my husband if he could help and he said 'sorry I have a meeting tomorrow' so I just have to figure it out.

At this point, Hanan directed the conversation toward me. She said:

Even though you are getting a Ph.D., I am sure that's not your primary focus. When a woman is getting a Ph.D., she still has a lot of pressure to be a mother first. But a man- if a man is getting a Ph.D., then his primary focus is going to be his Ph.D.!

I smiled and nodded at her statement.

Two mothers I interviewed described delegating duties to their children. Mona, who works full-time, explained that she "assigns chores." Surprisingly, she also admitted that she assisted her son but did not assist her daughter. She said:

> I do find myself being a little bit more traditional with her than my son when it comes to chores. For example, she empties the dishwasher, and my son loads it. They are supposed to do their chore holistically by themselves. She is expected to her part. But when it comes to my son, I am definitely more apt to stand there with him, and do it for him. When it comes to her, I am more apt to be like 'this is your chore you are supposed to do it." so I do find myself subconsciously doing this like that.

She continued to describe how she interacts with her children while reviewing their homework:

> And I do these things in reverse. Like with my son, I find myself being a bit more strict when it comes to grades. Like if my daughter got a B, it's fine. But if my son gets a B, I ask "why didn't you get an A?" Why am I like this? Is it because I think or know that my daughter will grow up and be a housewife maybe? It doesn't matter if she works because she will have a man take care of her. Whereas my son is the man who will need a good job to support a family?

Nahla also admitted to having a gender bias when delegating the chores of her children. She said:

> Maybe it is a bit gendered because my sons are responsible for taking out the garbage and loading and unloading the dishwasher, whereas my daughters are expected to like... clean the kitchen for whoever is cooking- whether it's me or my husband. They do general light cleaning like vacuuming the living room. We deep clean on the weekends. But the girls are also older so... I am not saying it's a perfect system, because most of the time, everything is falling apart [laughs] and someone is blaming someone else for not doing whatever they were supposed to do!

I asked both Nina and Mona to clarify which parent assigns their children chores. Both participants named themselves as the parent in charge of delegating tasks. Mona became particularly animated as she stated:

> It's me. I do everything. I work full-time, I control the finances, I do the disciplining. I do the delegating. I am an equal breadwinner- and yet I am still the one who is the nurturer, the career, the one who is concerned about their spiritual well-being. He's just not interested.

Both mothers describe duties that involve organizing day-to-day life in ways that allow the family to run smoothly. Even though these mothers may not be specifically involved in certain household tasks like cooking dinner, loading the dishwasher, doing laundry, or taking out the garbage, they are the ones interacting with their children to ensure it gets done.

· 6 ·

SACRIFICE AND FAILURE

This chapter focuses on the personal layer of identity and identity gaps. The personal layer of identity denotes how an individual understands and defines themselves. This layer is based on a conception that one has of their own values and characteristics and is expected to be somewhat consistent over time. The personal layer almost always transgresses the communal layer (Hecht & Phillips, 2021). For the respondents of this study, the innermost conceptions of self were informed by their broader designations as women, mothers, and Muslims. This is evident in how many of the women effortlessly move between using the personal pronoun "I" and "me" and the collective pronoun "we" to imply they were speaking for women or mothers. It was also not uncommon for the women to speak as a collective by making statements such as "as women" or "as mothers." These designations carry explicit and implied definitions that dictate how respondents experience relationships and perform their identity. Of course, due to the simple fact of being a complex human, there are bound to be some incongruences and contradictions between identity layers. Jung and Hecht (2004) refer to these contradictions and incongruences as identity gaps. Identity gaps can be distressing, increase tension, and cause feelings of being misunderstood (Jung & Hecht, 2004). In

the analysis of this data, I found two potential gaps that I will discuss in further detail later in this section.

Willing to Sacrifice

Firstly, I want to consider some of the implications surrounding the personal layer of identity, or specifically, how women perceive themselves in their innermost thoughts. In the previous chapter, I explained that the women described themselves as making purposeful decisions to sacrifice time, effort, careers, and professional goals to make their children and family a priority. The women either implied or explicitly explained that they were caring, nurturing, and "willing to sacrifice." These self-perceptions describe their personal layer of identity and directly cohere with their communal, relational, and enacted identities. This point is perhaps best illustrated in a statement from Rabia. She said:

> When I think about it [pause] being a mother and having the status that we have as mothers is directly connected to me being caring and loving to my kids. This is who I am as a person, as a mother, and as a Muslim.

In the first part of the statement, Rabia refers to the communal identity of "esteemed Muslim mom" when she refers to the "status" that mothers have. She then connects the relational and enacted identities by noting that this "status" is "based on her being "caring and loving" toward her children. Consequently, Rabia conceives her personal identity as a caring loving mother, person, and Muslim.

Hanan, like many of the other respondents, was not as explicit as Rabia. However, a careful analysis of the data showcases the same interconnections. In the below excerpt, Hanan connects the quality of being "loving to a child" to a larger communal identity of being a woman. She also uses the personal pronoun "we," citing a larger communal identity that she is personally a part of. She said:

> Mothers sacrifice a lot. We do a lot. Maybe we do too much. But at the same time, this is in us. We do it, and we don't mind. This is part of who we are as mothers. Not just as mothers, but as women. I have a neighbor who adopted a child. I see her and how loving she is to her child, even though it is not her biological child. That tells me that it's something that's just natural not just to the mother, but to the woman.

Hanan perceives herself as sacrificing and caring. She suggests that these features are part of being a woman, whether a biological or adoptive mother. There is no distance between the communal and personal.

Nahla, the mother of five, spoke about the expectations of the sacrifice are both "socially expected" and "natural." She said:

> I love my children very deeply and I am willing to give them whatever I can. But I love myself too. And I think that's taboo. I think it's taboo for a mother to love herself, or a woman to love herself. We are socially expected to be insecure on our own and have our identities attached to our children. I mean [pause] but I guess children do that to you. They make you vulnerable. It's natural to feel that you have to sacrifice yourself to protect them. Once you have children, it's over for you. Your dreams, your priorities [pause] take a backseat. It's about them.

Like Hanan, Nahla naturally refers to a collective motherhood identity when she speaks about the relationship she has with her own children. This is more evidence of how the communal identity, dictated and defined by larger social structures, imposes itself upon the most personal conceptions of the self. Nahla "loves herself" but believes it to be "taboo" to be a secure person on her "own." The implication is that the "taboo" is derived from an understanding of womanhood that is outside of the personal self.

Fearing Failure

When I was analyzing the data for themes connected to the personal layer of identity, the second most common sentiment was a fear of failure. The women implied or explicitly described concerns they had about not fulfilling their obligations as a mother. For many of the women, their identities as mothers are the most salient. For example, Lara reflected on how participating in my research project had caused her to consider the idea that she did have an identity outside of being a mother. She said:

> Talking to you has me thinking about how other than taking care of the girls, I really don't do too much. Me and my husband don't trust anyone to watch the kids so everything is on me. I don't want to say that I am "just a mom" because there is nothing wrong with being "just a mom," but maybe that's what I am.

She then continued to describe concerns she has about not fulfilling the expectations of that identity. She said:

> There is always this fear that I am not good enough because there is so much that I am expected to do for the kids' well-being. You ask yourself "Are they ok? Do they look good? Are they happy? Are they clean? Do they represent your family well when you take them outside?" You are responsible for everything: their education, their religion, their behavior. Everything is on you, as the mother. It's difficult having all of that you, so there is always this fear that you aren't doing enough, or you aren't doing it right.

Perhaps Lara is affected by the expectations that Nahla referenced. Women and mothers are supposed to be "insecure" and have identities attached to their children. Lara described herself as "just a mom" before expressing fears (or insecurities) that she is not "doing it right." I noted that Lara's fears of personally failing as a mother are also connected to a fear of being judged by others in the community when she states, "Do they represent your family well when you take them outside?" This statement reflects how individuals almost always seek belonging and acceptance from the group.

Lara's fears of being judged are shared by Mona. Notably, Lara and Mona are different kinds of mothers. Mona is a working, professional woman who described herself as an "equal breadwinner," whereas Lara described herself as a "stay-at-home mom." Nevertheless, they both expressed similar expectations for themselves, similar insecurities, and similar fears. Mona stated:

> As a mom, I would say that I do a lot because I see it as my duty, but I am also [pause] insecure [pause] or worried about how my kids and family are perceived. Or maybe how I'm perceived? I do feel like…let's say I didn't take the time and effort to teach my kids Qur'an and Islam…if at some point when they are out in the world, and someone finds out that they don't know how to read Qur'anic Arabic. they are not going to say "oh your dad didn't teach you?" They are going to say "your mom didn't teach you!" They are going to say "what kind of a crap mom are you?" Maybe they would look at the whole family … like collectively and say "what a crap mom and crap family".

Like Lara, Mona is concerned about her children representing herself and her family well. However, Mona goes further to remind us of the power a community has to shame and scandalize. Mona specifically mentions a fear of her children not knowing the Qur'an and Arabic. The implication is that knowledge of the Qur'an and Arabic signifies inclusion in the communal identity of being a Muslim. Perceived failure risks their expulsion and will be a direct reflection of her mothering. As she noted, they will not ask "oh your dad didn't teach you?"

Boran also implies that she has insecurities about providing her children with Islamic education. She noted:

> As a mother, I constantly worry. I am constantly afraid I am messing things up. we constantly hear things like "make sure your kids are on the right path. Make sure your kids are getting an Islamic education." And I struggle a lot with finding the right resources... and I struggle a lot with just getting my kid to sit down and read Qur'an.

Once again, there is a connection between the communal and personal when she states "as a mother." Although she is talking about herself, she references the communal identity. As a mother, she worries. She struggles. She fears she is "messing things up."

One excerpt from Hanan stood out as a reminder that the expectations that many of these women have for themselves transcend into the otherworldly. Hanan seems not as worried about her community judging her or her family but is worried about answering to God. She explained:

> All the choices I make are for the sake of God because one day I will stand before God and answer for these choices. God is not going to ask me "how were you in your career?" He will ask me about how I was as a mother. I am afraid to stand before God without a good answer.

Incongruences and Contradictions

Women place tremendous pressure on themselves to "do things right." They fear that failure could result in judgment, ostracization, and scandal. Such pressure is bound to result in some manufactured identity performances for some of the women. A personal-enacted identity gap emerges when there is a "perceived difference between an individual's self-view and his or herself as presented in communication" (Jung, 2011, p. 316). The data implies that many of the women strive to present perfect mothering identities while being deeply insecure and perceiving themselves as struggling and "messing things up." This suggests there is a personal-enacted identity gap, or rather, there is an incongruence between how they present themselves and who they perceive themselves to be.

Notably, some identity performances are much more blatant than others. I note a personal-enacted-relational gap described by several of the women. As explained in chapter three, Drummond and Orbe (2009) describe a

personal-enacted-relational identity gap reflects a "discrepancy between how one sees himself or herself, the face one actually presents to others, and the identity supported within one's relationship" (p. 84). This is illustrated in the following excerpts of Ameerah, Rabia, Boran, and Nahla.

Ameerah, more than any other woman I interviewed, struck me as the most disconnected from the traditional expectations of motherhood. Early in our interview, she made clear that before being a mother "I am a person first." Thus, I was quite surprised when a personal-enacted gap emerged when Ameerah described how she performs her identity in front of relatives. She said:

> If my mother knew how much my husband does around the house, she would be horrified! And when his mother is here, I make sure that I am 'on my toes'. I am up early, making breakfast, and doing housework. I don't let them see my husband doing anything. If my mother-in-law saw something like that she would be like "Oh my God, my son is in hell!" [laughs]

Rabia told a similar story. She explained that most of their relatives lived abroad and across the country. Whenever there are visits, Rabia performs the expected identity of "subservient wife" or "good daughter-in-law". She explained:

> So if we're around relatives: whether here or in Pakistan, then it's different, right? I play the role of a subservient wife, right? I am the good daughter-in-law. Like last time I had three small boys and ten relatives in my house. JoAnna, these people expect full-course meals three times a day. I complained to my husband, and he said "Rabia, it's just for a few days, you need to suck it up."

In front of relatives, both Ameerah and Rabia elect to perform their identities differently than whom they perceive themselves to be. Ameerah described being up early making breakfast while Rabia referred to her behaving as taking the "role of subservient wife." Identity gaps are described as causing distress and tension (Jung & Hecht, 2004; Kam & Hecht, 2009). However, for these women, I suggest the opposite is true. The personal-enacted-relational gap functions to relieve tension and avoid distress.

Two women also described a personal-enacted-relational identity gap in their public relationships with their husbands. Specifically, these women behave differently with their husbands in public than they do in private. Boran explained that her husband was a very active parent in the household but refused to show this dimension of himself publicly. She explained:

> I don't want to embarrass my husband and he doesn't want to be embarrassed. In the household, he is very helpful, but if we are in front of people- specifically people from our community [pause] like Muslims or other Pakistanis [pause] I don't ask him to do anything…

Like Boran, Nahla also described a husband who is very "hands-on," in the house, but this behavior is subject to change when in front of others. She noted:

> When we would visit my in-laws or other Arabs my husband was just not as conscious of what the children are doing or what they are getting into. At home I am used to him being there, being aware [pause] but if we are visiting, he just completely shuts down and is into his conversations or whatever he is doing. And we had five children, so I would be the one scrambling to feed them, fix their plate [just like all the other moms and women [pause]. In Muslim social events, men and women are segregated, and as you know, the children are always on the women's side. It doesn't matter if you have 10 children, they are on the women's side! [laughs]

I note that all these women described this inconsistency in identity as occurring only while in the presence of others. Drummond (2009) explains that a gap between one's personal and enacted identities is likely to occur when the personal identity is steeped in a negative stereotype. Ameerah does not want to "horrify" her mother-in-law, thus she enacts her identity in a way that misleads her. Rabia cooks and serves the extended family because she does not want to upset the family dynamic. Likewise, Boran and Nahla both enact their relationships with their husbands differently in private than they do in public to avoid shame and criticism from their community. They aim protect the public dignity of their husbands by not making domestic requests of them in front of others.

Finally, I want to discuss the personal-communal identity gap that clearly emerged in my conversations with Mona. A personal-communal gap occurs when an individual is assumed to possess certain identity characteristics as a member of a certain group, but these characteristics conflict with the individual's identity as practiced or performed in the real world. Specifically, Mona made clear that she was discussing identity attributes of Muslim mothers and fathers "theoretically," as "what is supposed to be and what actually happens is not the same." She went on to describe her identity within in her own family as unique, stating:

> What happens in my family is not the norm for Muslim families. I am an equal breadwinner. I control the finances. I am in charge of everything.

Mona was also the only respondent who expressed distress and shared some concerns that might make her family or Islam "look bad." Mona did not want to represent Muslims negatively. Wen (2019) holds that it is "essential for the individual's self-view to be consistent with his or her community's or group's identity" (p. 15). When this doesn't happen and people do not see themselves as accurate or proper reflections of that community then their psychological well-being can be affected (Jung, 2011, 2013; Wen, 2019). The disconnect between the communal expectations of motherhood, and Mona's personal life caused her distress.

· 7 ·

FINAL REFLECTION

In this project, I identified themes in the data and made connections to one of the four layers of identity as described by Hecht (1993). I specifically noted how the communal identity of "esteemed Muslim mom" interpenetrated and influenced all other layers of identity. The "esteemed Muslim mom" described the identity rooted in Islamic scripture. This is consistent with Van Dijk's (1995, 1998) premise that ideological beliefs are expressed through communicative identities. Both Islam and Motherhood can be defined as ideological constructs.[1] I also noted how the "esteemed Muslim mom" was consistently contrasted with the "culturally oppressed mom." This is indicative of a tendency of the respondents to protect Islamic ideological beliefs about the mother. Simply put, women's oppression and unbalanced division of labor are blamed on "culture." The data also found that respondents discussed efforts to fulfill the idealized identity of "esteemed Muslim mom" even as the actual lived conditions of their lives make it almost impossible. In sum, I found three major issues that are worthy of discussion: (a) the power of Islamic ideology in shaping women's mothering identities; (b) the efforts of respondents to protect the image of Islam; and (c) how the illusion of ideology obscures the lived experiences of the mothers that participated in this research project.

Ideology and Identity

Hajer (2021) argues that while "on the surface" the concept of ideology and identity appear to be independent concepts, Van Dijk's approach to discourse analysis aids in unveiling the link between the two (p. 39). Specifically, Van Dijk (1995, 1998, 2009) describes ideology as informing the social practices of the community and family, which in turn, informs the subjective understanding of the self (identity). He explains that ideology is cognitive, meaning that there is an internal effect on the mind (1995, 1998). Our ideologies affect our feelings, our emotions, and our beliefs about certain issues. Additionally, our ideologies affect how we see ourselves and our relationships with other people. The power of ideology to inform the identities of the participants of this research project is evident in how the communal identity of "Esteemed Muslim Mom" dictated how the women conceptualized all other layers of their identities.

Specifically, all nine respondents discussed "Islam" as holding mothers in high esteem. All nine repeated variations of the adage "Paradise is under the mother's feet." Nahla describes the mother as being almost "next to God in terms of respect and love." Seven participants mentioned that mothers were owed "three times" the respect and love of the father. The ubiquitousness of these phrases are consistent with CDA's premise that any discourse is always drawn from other discourse (Fairclough, Mulderrig, & Wodak, 2011). As members of a Muslim community and practitioners of the faith, these women had either read about the status of Muslim mothers or heard it from family or other community members. When I asked Manar to recall where she had heard the saying "Paradise is under the mother's feet" she could not remember. She responded "I am not sure! I have just always known it." Due to the commonalities of these adages, respondents sketched an image of an "Esteemed Muslim Mom" who is respected and honored.

Notably, the "Esteemed Muslim Mom" is not conceptualized without conditions. Respondents tended to connect this honored status to duties and tasks that mothers perform for their children. Both Hanan and Lara expressed the idea that a woman possesses essential characteristics of nurturing and motherhood based on her biological disposition of a woman. For example, Hanan explicitly stated: "this quality of caring, or mothering, is naturally part of being a woman. It's how God made us." Another respondent, Zainab, explained that this high respect a mother is because the child is the mother's "primary obligation." Unsurprisingly, all nine women tended to explain their

relational identities as based on the "rights" of children and the "obligations" of mothers. Mona most succinctly put it when she stated:

> A mom is the one responsible for pretty much everything that has to do with the kids. Their education, their spirituality, their safety. Moms make sure they pray, make sure they're studying, that they're clean, that they aren't watching inappropriate shows on TV. All those obligations are on the mother.

The enacted identity interpenetrates the relational layer; thus, the respondents naturally performed their identities in ways that reflected the relational layer. Additionally, they tended to view the role of the husband and father as "provider," "protector," and "religious example." Specifically, since the mothers' primary obligation is to care for the children, the fathers are expected to financially provide, physically protect, and be the leader of the family.

Most notably, when conceptualizing their most personal mothering identities, respondents aimed to fulfill the conditions of the idealized "Esteemed Muslim Mom." All nine participants describe themselves as embodying Islamic values of motherhood within their own personal belief systems. They describe themselves as "caring," "nurturing," and "willing to sacrifice" careers, time, and personal autonomy. At the same time, five mothers explicitly or implicitly expressed fear of failing in fulfilling their mothering obligations as dictated by Islamic ideology. For example, Hanan explained her belief that she will stand before God to be questioned about her mothering abilities. She said:

> God is not going to ask me "How were you in your career?" He will ask me about how I was as a mother. I am afraid to stand before God without a good answer.

This sentiment hearkens towards Hamed's (2016) study that examined the narratives of Muslim mothers against the backdrop of a seemingly empowering adage: "The mother is a school." Hamed described her study participants as also feeling though they were failing as both mothers and Muslims. Overall, findings demonstrate the power of an ideological belief to permeate the complex, unstable, and fluid layers of individual identity.

Protecting Ideology

Van Dijk (1998) asserts that since membership in a group is associated with ideology, group members are invested in protecting and reinforcing what they

believe is the truth of that ideology. This argument is consistent with the tendency of the respondents to make a distinction between "Islam," and what they referred to as "culture." Seven respondents were quick to point out that when Muslim women are tasked with an unequal division of housework it is due to culture and not "Islam." For example, Zainab stated:

> Islam is balanced with the roles for men and women. Sometimes I feel like there is an imbalance, but that's culture. When you see a mother doing 90 percent of the childcare and housekeeping, you have to think about it [pause] ask yourself is that Islam or is that culture? It's culture!

When following this line of inquiry, respondents raised their voices, shifted their body posture, and expressed heightened levels of emotion. Some participants used terms such as "immigrants" "back home mothers" or "village women" in derogatory ways while describing cultural influences on Islamic conceptions of womanhood or mothering.

Also, as both a Muslim woman myself and a researcher of Muslim life, I am aware of the prevalence of stereotypes and assumptions about Muslim women being subservient, oppressed, and powerless (Arjana, 2018; Said, 1980; Shaheen, 2009). Lipmann (1922) called stereotypes "maps of the world" to exemplify a human inclination to categorize individuals as members of groups and assume they possess the perceived characteristics of that group. Research demonstrates that Muslims are aware of negative stereotypes and how they tend to be viewed by outsiders (Bilici, 2012). Consequently, targets of stereotypes might make efforts to distance themselves from the stereotype. Perhaps this is best exemplified in a comment by Nahla who described other Muslim women in the mosque as "grouchy immigrant women who are bitter and oppressed by their husbands." In this statement, Nahla coupled these women's "immigrant" identity with an assumption that they are "oppressed by their husbands." In other words, any oppression that these women might experience is related to them being immigrants. Thus, as respondents made distinctions between "Islam" and "culture," I detected an effort to contest the stereotype of an oppressed Muslim woman and protect what is perceived to be the "truth" of Islamic ideology. If any woman is "oppressed" it's not because she is Muslim.

Van Dijk (1998) further explains that ideological domains are "sites of domination, struggle, conflict, and interests. Domains may be ideologically protected by groups as their domain, in which other groups should not interfere" (p. 215). In other words, group members tend to be protective of

their ideology from outsiders, even if some members are internally critical. I argue my insider status as a Muslim woman and mother facilitated an atmosphere of camaraderie and sisterhood. Respondents were generally eager to sit down with me and work on a project that dealt specifically with the lives of Muslim mothers. However, my respondents were also aware of my role as the researcher and the fact that I would be writing about Muslim motherhood for "outsiders." Drawing a distinction between "Esteemed Muslim Mom" and "Culturally Concepted Mom" functioned as a means to uphold the ideology of Islam while critiquing what actually happens in Muslim families.

Illusion of Ideology

Finally, I argue that ideology can obscure reality. In other words, ideology holds "forms of illusion" which means that ideological teachings compel members to have certain mental images in their thoughts (Wood, 1988, p. 355). I specifically consider how respondents perceive the "esteemed Muslim mom." This identity is conceptualized based on explanations attached to variations of two oft-repeated phrases: "Paradise lies at the feet of the mother" and "Mothers are owed three times the respect of the father." I suggest that these are rhetorical devices meant to amplify the idea of Islam holding mothers in the utmost esteem. When provoked to expand on the "high status" Islam holds for mothers, all respondents connected the perceived high status to the mother's obligations toward her children. To be clear, I am not at all condemning women for prioritizing the needs of their children, but I resonate with the words of Wadud (2006) who argued:

> "Paradise lies at the feet of the mother" is just an expression. It is not an actual goal to be achieved by policy, economic structures, and legal codes, especially in neoconservative circles and other places of male privilege (p. 125).

In other words, "Paradise lies at the feet of the mother," is an abstract phrase. The sentiment inspires feelings and ways of thinking which can filter our collective perception. There is no doubt that, on the surface, it is an empowering adage that inspires positive feelings and personal validation. But what impact does it have on a real woman's life? It doesn't relieve her of the expectations of carrying out most childcare and domestic duties regardless of whether she works outside the home or not. In most households, there is still an unequal division of labor. Wood (1988) explains that ideology operates by:

> Affording people a systematically biased selection of correct information, by distorting ways of processing the information they have, and by encouraging associations between reality and certain sentiments or effectively colored images (p. 355).

This tendency to encourage "associations between reality" and "certain sentiments" is reflected in how my respondents draw upon the perceived obligations of the "esteemed Muslim mom" to fashion their personal mothering identities. Six women described lives dominated by obligations toward the home and family, but they tended to attribute any imbalance or unequal division of labor to their own characteristics of being "caring," "nurturing," and "willing to sacrifice." Any criticism of these conditions was cloaked in mentions of "culture." This argument is consistent with Van Dijk's (1998) position that ideologies can conceal real social relations and serve to deceive (p. 2).

As I conclude this section, I refer to a conversation I had with Ameerah. Ameerah is one of two respondents who regularly employs a housekeeper and devotes personal time to her own projects. The conversation took place during a second interview that took place over Zoom. She shared:

> You know, I was thinking that it is ironic that all the expectations and obligations of motherhood prevent a woman from really being a mother. Do you know what I mean? You can't be a mother in a natural, organic way because the role is already dictated to you. Sacrifice, sacrifice, sacrifice. So then who are you? Who are you as a person? What are you interested in? What are your talents? The person gets lost.

This sentiment is reflective of Ruddick's (1990) argument that motherhood becomes a "consuming identity requiring sacrifices of health, pleasure, and ambitions unnecessary for the well-being of children" (p. 29). Five of my respondents described child-centered lives. What room does that leave for developing other interests, hobbies, and other facets of the self? Of course, I do not mean to suggest that there is anything inherently wrong about the idea that Islam affords mothers a "high status" but how does it manifest? According to the data of this study, it manifests in women striving to embody the characteristics of the mother that is worthy of this status.

Methodological Implications

Methodology can be defined as "a theory and analysis of how research does or should proceed" (Harding, 1987, p. 3). One of the first aspects of any methodology is making decisions about how to gather the evidence. I approached

this project as both an investigator and an insider. Saidan and Yaacob (2017) suggested that insider researchers can better establish a rapport with the subjects and put them at ease. Additionally, my insider status means that I have some background knowledge and context of my participants' explanations and insights. This proved useful considering Paget's (1983) perspective that an interviewee's responses are often "inherently biased in favor of their own values and interests" (p. 78). In other words, just as a researcher approaches the research with biases, so does the individual who is being researched. Having insider knowledge meant that I was more aware of complexities and contradictions in the issues that we were discussing and provoked me to probe deeper into my respondents' narratives. Campbell et al. (2013) notes that when decoding, the interviewer needs to be "knowledgeable enough about the subject matter in question to identify subtle meanings in the text" (p. 297).

Practical Contributions

This project aimed to counter the absence of women's perspectives in conversations about Muslim motherhood. In my own life experience as a Muslim woman, I have noticed that discussions of mothering and motherhood are dominated by male religious scholars and based on a scriptural interpretation of the Qur'an and hadith. Narratives from actual women seem to be almost completely absent from the conversation. This study centered on those perspectives and determined that adages meant to uplift mothers can actually place an unfair burden on them. The result is anxiety, stress, and possible spiritual disenchantment. This study concurs with Hamed's (2016) argument that placing unreasonable expectations on the Muslim mother can alienate her from religious growth. Her inability to fulfill the imagined obligations of motherhood can result in a state of anxiety and confusion.

This research contributes to motherhood studies and answers the call for a greater diversity of studies (Kawash, 2011; O'Reilly & Porter, 2006; Takseva, 2018). Studies on motherhood have historically centered on the perspectives of White middle-class academics critiquing a "particular brand of Western patriarchy" (Takseva, 2018, p. 182). However, the experience of mothering is not a singular practice and cannot be understood as a monolithic category. This study on U.S. American Muslim mothers has significant implications for how to understand the relationship between ideology, identity, and personal

agency in the lives of women who are outside of the mainstream conception of motherhood.

Finally, the nine participants likely benefitted from sharing their thoughts and reflections. Piliavin and Siegl (2007) concluded that volunteering in studies increases psychological well-being partly because it leads people to believe that their life has meaning and that they have an important role in society. Furthermore, discussing motherhood for this research project compelled participants to engage with the subject in a new way. As a result, participants were likely to have gained new thoughts, opinions, insights, and emotions. It is my hope that participants found meaning in the interview experience and are motivated to contribute to any changes they aspire to see happen in either their personal lives or in the broader community. Rodgers (2015) holds that "the creation of meaning out of experience is at the very heart of what it means to be human. It is what enables us to make sense of and attribute value to the events of our lives (p. 848).

Limitations

I approached this project as an insider, and I opted for an unstructured interview approach. While this approach is lauded with several advantages, there are also disadvantages that create limitations. For example, in unstructured interviews, respondents guide the conversations. As a result, they make choices about the direction of the conversation and the extent to which they choose to respond to interview prompts (Bryman, 2008). Alsaawi (2014) cites Arvey and Campion (1982) who argue that one disadvantage of unstructured interviews is that their open-ended nature may cause respondents to become guarded and deem it risky to "share personal information about sensitive topics" (p. 155). Consistent with this limitation, I observed that some participants seemed insistent to direct the conversation in a particular way. Notably, the women consistently portrayed a desire to discuss the differences between "Islam" and "culture." There were instances in some interviews in which the respondent seemed reluctant to discuss personal details about their own upbringing or specifically call out problematic behaviors of their own mothers or families. Instead, they elected to frame their upbringing around the context of "culture." For example, Rabia described her mother as a "cultural Muslim woman" who was "essentially a slave" but refrained from going into details about her definition of "slave." When I tried to provoke her into

saying more by stating "go on," she responded with a rhetorical question: "It's a cultural issue, right?" and then redirected the conversation toward her own personal efforts to practice a more "authentic" and truer form of Islam. In other words, she returned to the theme of the "Esteemed Muslim Mom" versus the "Culturally Concepted Mom."

Furthermore, Rabia's question: "It's a cultural issue, right?" denotes a second possible limitation of this study. Saidan and Yaacob (2017) point out that when the interviewer is an insider, participants may assume that the researcher "already knows what they know" (p. 852). This means that the participant may skimp on details because they assume that the interviewer is fully aware and able to understand the issue that is being referenced. I note that this happened in all instances with my respondents whenever they would refer to "culture." They did not bother to explain the meaning of "culture" unless I provoked them. My respondents were ethnically diverse which almost led to me automatically assuming that they were referring to the "culture" of their parents. However, I was careful to check the definition by asking respondents to explain what they meant by "culture." When prompted to expound, the data shows that some respondents did not have any particular culture in mind at all. They were simply referring to the presence of immigrants in the U.S. American Muslim community. For example, when I asked Manar to clarify the meaning behind her use of the term "culturally," she responded:

> Foreign Muslims! [emphasis] I think in our community it is the strong presence of these foreign-born Muslims from these eastern countries. Arabic-speaking countries. Hindi-speaking countries. Urdu-speaking countries. East African countries.

In the above example, Manar had no particular "culture" in mind at all. She was using the term to describe the influence of people from many different countries outside of the United States.

Another problem of being an insider is that some respondents may have felt uncomfortable speaking negatively about certain family members out of fear that I might personally know their family members. This limitation is best exemplified by Mona, who was very direct in communicating her reservations about sharing private information about her family with me. For example, at one point in the interview, it appeared that she was going to make a statement but hesitated before stating "I don't want to talk crap about my family." I reminded her that everything was confidential, but she noted "I know but still. You know my mom. I am sure you have seen her around at events and stuff. I don't want it to be weird the next time you see her [laughs]." Mona was

referring to our social membership in the same mosque community. Even with the assurances of confidentiality, Mona was concerned about me running into her mom and it being "weird."

Another possible limitation of my insider status is that my position as a U.S. American Muslim mother is likely to influence the interpretation of results. The fact that I understand the experiences of raising children as a Muslim within a Muslim community suggests that I may be inclined to represent results in a way that agrees with my own opinions. It may also mean that the data collection process was designed in a way to lead toward specific conclusions. However, I argue that the benefits of my insider status mitigate these limitations. I understand the context and background of the topic which allowed me to process the data more accurately and efficiently.

Additionally, while there were several stated advantages of the diversity of my participants' ethnicities, I note a glaring limitation. My participants included four South Asians, two Arab Americans, two White women, and one African American. A careful analysis of the data reveals that the most extensive and passionate conversations about the relationship between culture and Islam came from the four South Asian participants and the two Arab-American participants. This suggests that there are conditions and circumstances that are unique to those specific identities that could not be adequately addressed by a study focused on capturing the religious dimension of their identities as "Muslim" women.

This research project also does not cover the perspectives of Muslim mothers with special needs children. Boran specifically discussed some concerns that were unique to these circumstances and were not adequately addressed nor captured by the motivations of this study. Likewise, this study does not cover the perspectives of adoptive mothers, foster mothers, or other types of mothers who fall outside of mainstream normative conventions of motherhood.

All the respondents were married. I requested married respondents because when I initially conceptualized this project, I imagined that I would also interview husbands. However, after the first four interviews, I decided to change the direction and goals of the project. Husbands were described as unavailable due to busy work schedules. Finally, I took a cue from Rabia who shared her opinion that women would speak more freely and openly if they perceived this project as a "women's only endeavor." In any case, due to my initial objective of pursuing married couples, this project did not capture the perspectives of divorced, widowed, or never-married mothers.

Finally, the findings of this research project are not generalizable to studies on Muslim mothers from other countries and regions due to a variety of differences that include race, ethnicity, socio-economic class, geography, and marital status. This study focused on a specific mosque community in the mid-southern region of the United States. The findings of this research project are not generalizable to studies on Muslim mothers in other countries and regions due to a variety of differences in language, culture, social class, and life experiences. The findings are also not necessarily generalizable to the communicative experiences of Muslim mothers in other mosque communities; whether those communities are in other regions of the United States or located in the same city. Different communities have different community members with their own unique experiences and perspectives.

Future Directions

Future studies on U.S. American Muslim mothers could seek to address the limitations that are described above. The women in this project were from diverse backgrounds, isolating Islam as the unifying identity. Future studies could narrow the perspective to ethnicity, race, class, or immigrant status. For example, future research could explicitly examine the narratives of South Asian or Pakistani Muslim mothers, professional Muslim mothers, or mothers who converted to Islam. Additionally, future studies could seek the perspectives of unmarried, divorced, widowed, or adoptive Muslim mothers. Different social circumstances shape different motivations and life experiences.

Another possible future direction could be to interview fathers, or adult children to gain perspectives of motherhood from other members of the family. It may also be useful to conduct joint interviews with married couples, mothers with their adult children, or group interviews with entire families or several mothers at a time. Morgan (1994) has argued that one of the advantages of interviewing individuals together is that they have the opportunity to "query each other and explain themselves to each other" (p. 139). Any of these directions could illicit new and various perspectives on the subject of Muslim motherhood as experienced in the United States.

Finally, I suggest that one goal of future research could be to address the material circumstances of Muslim women's lives that would prevent them from having power and voice in their local communities. Seven of my participants indicated that it was extremely problematic that there was a lack

of perspectives shared by Muslim women in mainstream conversations about Muslim motherhood. Consequently, two mothers expressed feeling isolated and estranged from the mosque and no longer attended weekly sermons (although they continued to attend social events.) All respondents agreed that there was not enough support for Muslim mothers or parents. They also agreed that women did not have any substantial voice in the community. As Boran said "In our communities, we only hear from the men."

Researcher Reflections

The data collection process was the most intensive and crucial part of this research project. It began when I sent emails to various contacts and asked that the email be forwarded to those possibly interested in participating. Initially, I intended to interview married couples. Due to the gendered dynamics of the Muslim community, I decided that it was more appropriate for me to direct my first email to married mothers, arrange an initial interview, and later ask the wife if it would be possible to interview the husband. As I explained in Chapter Three, after my first four interviews I adapted the goals of my research to only include mothers. Respondents explained that it was impractical for their husbands to attend due to busy work schedules. Two women did not want their husbands to find out they were participating in the interview. Another insisted that it would "mess up the data" if I included husbands because the women would not feel free to speak. I was eventually inspired to reconceptualize my project as a "women's only" endeavor.

All participants seemed initially excited to participate in my project and expressed an eagerness to sit down with me to discuss "Muslim motherhood." This could have been due to the social climate created by the COVID-19 pandemic. My interviews took place between June and August of 2021. By this time, the public had experienced over a year of quarantine and social distancing. Four respondents insisted on meeting in person. By inviting me into their homes, I sensed a desire for socialization and connection. For example, when I told Rabia that we could conduct the interview over Zoom she responded "Are you kidding? Please come over. I need a girls' day!". Nahla, similarly, responded, "just come over. I wanted to get to know you anyway." Five respondents opted to meet over Zoom. However, these respondents also sounded cheerful and excited in text messages and emails exchanged prior to

the meeting date. Messages include sentiments such as "I can't wait!" and "I look forward to it!"

Despite the initial eagerness, I noticed that enthusiasm seemed to slightly wane by the time we met for the interview, and the participant was tasked with reading and signing the consent form. Several participants seemed burdened with the idea that they were representing "Islam" or "Muslim" mothers. For example, at the very beginning of her interview, Rabia makes clear that she sees herself as a "cultural" Muslim, and, thus, may not be the "best person" for the interview. I shared that as a researcher and a Muslim, I recognize that there is no one way to practice Islam or be a Muslim. I explained that based on this project's conception of Islam, she is a Muslim.

Two participants named other women as more suitable examples of Muslim mothers. Lara asked whether I knew Boran. When I told her that I did, she (Lara) said that she would encourage Boran to reach out to me. As a white convert, Lara expressed her feeling that Boran, a born Muslim, would be a "better example" because she was "born into the religion." Similarly, Mona noted that she would ask Hanan to email me stating that she would "give me a better picture" because she was more "practicing." Mona who does not wear a head scarf, mentions that Hanan does. It seemed that participants were concerned about portraying Islam and Muslim women accurately and in the most positive light.

Mona's opinion that Hanan would give me a "better picture" of the lives of Muslims is particularly ironic considering that during Hanan's interview, there was a moment in which she stated, "maybe I am not the best person to talk about this." During this point in the interview, she was specifically describing working three hours a day and being fully responsible for dropping off and picking up her children from their various activities. She shared how she had asked her husband if he could help, and he responded with "Sorry I have a meeting." Hanan told me "So I guess I just have to figure it out" before looking down, lowering her voice, and stating "maybe I am not the best person to talk to about this." I deduced that Hanan felt embarrassed about sharing her husband's response and was concerned about creating a negative image of Muslim life.

I noted that Boran was particularly steely in the first moments of our interaction. At the very beginning of the interview, she clarified her position that issues surrounding the obligations of "motherhood" transgressed religion. She was compelled to tell me that it was "not just a Muslim issue but a social issue." My identity as an insider prompted me to assure Boran that I shared

her perspective and fully agreed. As I explained in the first chapter, I believe that a significant contribution of a study on Muslim mothers is *sameness* to other studies on motherhood. It seems that women from various religious, racial, and cultural backgrounds tell a very similar story. As the interview progressed, Boran became increasingly relaxed and more open about sharing her personal struggles as a mother of a special needs child. That information was not shared in this analysis but (as I explained previously) could be a focus of future research.

Overall, the nine participants shared detailed thoughts about what Islamic scripture says about Muslim motherhood, the role of culture, rights, and obligations of different family members, and discussed details about their own day-to-day parenting lives. However, I admit that the information I gathered is somewhat limited due to the nature of the research project. We sat down to discuss motherhood, Islam, parenting, and children. As a result, there are dimensions of each woman's identity (outside of the family) that were not fully captured. I also acknowledge that the unstructured, or informal, nature of the interviews may have caused me, the researcher, to refrain from asking questions that may be considered "too personal" out of an unconscious fear of offending women who seemed (at least initially) eager to start a friendship. For example, I refrained from asking probing questions about the women's relationships with their husbands. Whenever a respondent redirected a question away from her personal life, I followed her lead and did not "push." Our shared identity as Muslim women and our membership in the same mosque community cultivated an atmosphere of camaraderie so I may have been unconsciously affected by social norms of politeness. In other words, if there was a greater social distance between myself and my participants, I may have felt bold enough to ask deeper questions. In short, the data cannot tell the story of who these women are as lovers, wives, professionals, and community members.

Conclusion

This research project achieved its principal goal of enhancing understanding of U.S. American Muslim women's communicative experiences of identity. As a Muslim woman myself, it was critically important to me to successfully execute a study that centered on the perspectives of everyday Muslim women who discuss motherhood in their own words. This study marks U.S. American

Muslim mothers as a category worthy of centrality and interrogation and challenged the stereotype of Muslim women as a monolithic group who are silenced and deprived of individual agency by Islamic religious authority (Arjana, 2018; Haddad, 2006; Said, 1978; Sinno, 2015). This study also achieved its goal of contributing to the literature on motherhood, as well as literature on Muslim women. It also showcases the applicability of the Communication Theory of Identity (CTI) to a community of Muslim women.

In sum, participants described a communal mothering identity grounded in high status and esteem but corrupted by various cultural influences. They described relational identities based on "rights," "obligations" and roles that each family member has toward the other. They enact their identities based on these relational roles. Personal identities cohere with their communal identities as Muslim mothers. I found three major issues that are worthy of discussion. These issues included: (a) the power of Islamic ideology in shaping women's mothering identities; (b) the efforts of respondents to protect the image of Islam; and (c) how the illusion of ideology masks the lived experiences of the mothers that participated in this research project. Overall, despite various limitations, this project achieved the aim of addressing the lack of research on U.S. Muslim American mothers and resulted in significant findings that may form a basis for future research.

Final Thoughts

Many years ago, I found myself as a new mother and a Muslim woman actively involved in her religious community. I recall sensing an inherent disconnect between Islamic texts about the status of Mothers and the messy, chaotic, emotional lives of the mothers around me. When we teach our community that paradise lies under the feet of the mother, do we learn to respect mothers, or do we put pressure on mothers to become women who are worthy of paradise? Or is the truth somewhere in between?

I conclude this dissertation with the words of Muslim woman scholar Amina Wadud. Wadud (2006) writes:

> I have a painful response and long experience with the oft-cited prophetic statement, 'Paradise lies at the feet of the mother,' a saying pretending that unconditional honor belongs to the one whose biology was created with the capacity to hold life under her breast and then in due time release it. It has been my nemesis, I suppose, for I have struggled in the public space to argue for the dignity and honor of every Muslim

woman while I have suffered at home to maintain the care and nurturance of those to whom I am mother without knowing the ways to bridge the great schism this has created in my own identity as Muslim woman and mother (p. 125).

Wadud's words resonate as here is a Muslim woman speaking plainly about her experience as a mother amidst discourse dominated by Islamic male clerics. Over the years, my own life experience determined that discourses about Muslim motherhood are missing the input of actual Muslim mothers. This research project sought to rectify that omission by humbly including Muslim mothers in the conversation.

Notes

1 Hajer (2021) explained that ideologies are belief systems that involve thoughts, values, and judgment. The main objective of ideologies is to organize social group attitudes. Hajer, A. (2021). Ideology and identity: Operating together. *European Journal of English Language and Literature Studies*, 9(7), 39–48.

BIBLIOGRAPHY

Abu-Lughod, L. (1998). *Remaking women: Feminism and modernity in the Middle East*. Princeton, NJ: Princeton University Press.

Aguiler, J. L. (1981). Insider research: An ethnography of a debate. In D. A. Messerschmidt (Ed.), *Anthropologists at home in North America* (pp. 15–26). New York NY: Cambridge University Press.

Ahmed, S. (2016). *What is Islam?* Princeton, NJ: Princeton University Press.

Al-Attas, F. (2016). Confinement practices of young Malay Muslim mothers. In M. A. Pappano & D. M. Owan (Eds.), *Muslim mothering: Global histories, theories, and practices.*. Toront, ON: Demeter Press.

Al-Faruqi, M. J. (2000). Women's self-identity in the Qur'an and Islamic Law. In Gisella Webb (Ed.), *Windows of faith: Muslim women scholar-activists in North America*. Syracuse, NY: Syracuse University Press.

Alsawwi, A. (2014). A critical review of qualitative interviews. *European Journal of Business and Social Sciences*, 3(4), 149–156.

Arjana, S. R. (2018). *Veiled superheroes: Islam, feminism, and popular culture*. Lanham, MD: Lexington Books.

Arvey, R. D., & Campion, J. E. (1982). The employment interview: A summary and review of recent research 1. *Personnel Psychology*, 35(2), 281–322.

Barlas, A. (2002). *Believing women in Islam: Unreading patriarchal interpretations of the Qur'an*. Austin, TX: University of Texas Press.

Barth, K. (2016). *El ghorba fil gharb: Conceptualizing ethnic identity with Saudi women graduate students in the US*. The University of Memphis Proquest Dissertation Publishing.

Baxter, L. A., & Braithwaite, D. O. (2008). Relational dialectics theory: Crafting meaning from competing discourses. In D. O. Braithwaite & L. A. Baxter (Eds.), *Engaging theories in interpersonal communication: Multiple perspectives* (pp. 349–361). Thousand Oaks, CA: Sage Publications.

Bazaz, N. (2016). 'God as my Witness': Mothering and militarization in Kashmir. In M. A. Pappano & D. M. Owan (Ed.), *Muslim mothering: Global histories, theories, and practices*. Toronto, ON: Demeter Press.

Bergen, K. M., & Braithwaite, D. O. (2009). Identity as constituted in communication. In W. F. Eadie (Ed.), *21st century communication: A sourcebook* (pp. 165–173). Thousand Oaks, CA: Sage Publications.

Bhaba, H. (1994). *The location of culture*. London and New York: Routledge.

Bilici, M. (2012). *Finding Mecca in America: How Islam is becoming an American religion*. Chicago, IL: University of Chicago Press.

Blumer, H. (1969). Symbolic interactionism. *Contemporary Sociological Theory, 62*.

Borman, E. (1989). *Communication theory*. New York: Holt, Rinehart & Winston.

Boylorn, R. M., & Orbe, M. P. (2014). *Critical autoethnography: Intersecting cultural identities in everyday life*. New York, NY: Routledge.

Bryman, A (2008). Why do researchers integrate/combine/mesh/blend/mix/merge/fuse quantitative and qualitative research. *Advances in Mixed Methods Research, 21*(8), 87–100.

Buchanan, L. (2013). *Rhetorics of motherhood*. Carbondale, IL: Southern Illinois University Press.

Campbell, J. L., Quincy, C., Osserman, J., & Pedersen, O. K. (2013). Coding in-depth semistructured interviews: Problems of unitization and intercoder reliability and agreement. *Sociological Methods & Research, 42*(3), 294–320.

Carbaugh, D. (1996). *Situating selves: The communication of social identities in American scenes*. Albany, NY: Suny Press.

Cheruvillil-Contractor, S. (2016). Motherhood as constructed by us: Muslim women's negotiations from a space that is their own. *Religion and Gender, 6*(1), 9–28.

Chodorow, N. (1979). *The reproduction of mothering: Psychoanalysis and the sociology of gender*. Berkeley, CA: University of California Press.

Ciblis, L. (2017). The discourse of parental involvement and the ideologies of motherhood. *Counterpoints, 439*, 53–78.

Clarke, A. M., & Jack, B. (1998). The benefits of using qualitative research. *Professional Nurse, 13*(12), 845–847.

Collier, M. J. (1998). Researching cultural identity: Reconciling interpretive and postcolonial perspectives. In D. V. Tanno & A. Gonzalez (Eds.), *Communication and identity across cultures* (pp. 122–147). Thousand Oaks, CA: Sage Publications.

Collier, M. J., & Thomas, M. (1988). Identity in intercultural communication: An interpretive perspective. In Y. Y. Kim & W. Gudykunst (Eds.), *Theories of intercultural communication* (pp. 99–120). Newbury Park, CA: Sage Publications.

Collins, P. H. (2005). Black women and motherhood. In S. Hardy & C. Wiedmer (Eds.), *Motherhood and space*. New York, NY: Palgrave Macmillan. https://doi.org/10.1007/978-1-137-12103-5_9.

Collins, P. H. (2008). *Black feminist thought: Knowledge, consciousness, and the politics of empowerment*. New York, NY: Routledge.

Corbin J., & Strauss, A. (1990). Grounded theory research: Procedures, canons and evaluative criteria. *Qualitative Sociology, 13*(1), 3–21.

Corbin, J., & Strauss, A. (2007). *Basics of qualitative research: Techniques and procedures for developing grounded theory* (3rd ed.). Thousand Oaks, CA: Sage Publications.

Craddock, K. T. (2015). *Black motherhood(s) contours, contexts, and considerations*. Toronto, ON: Demeter Press.

Creswell, J. (1998). *Qualitative inquiry and research design: Choosing among the five traditions*. Thousand Oaks, CA: Sage Publications.

Creswell, J. W. (2014). Qualitative inquiry and research design: Choosing among five traditions (3rd ed.). Thousand Oaks, CA: Sage Publications.

Creswell, J. W., & Creswell, J. D. (2018). *Research design: Qualitative, quantitative, and mixed methods approaches*. Los Angeles, CA: Sage Publications.

Creswell, J. W., & Miller, D. L. (2000). Determining validity in qualitative inquiry. *Theory into Practice, 39*, 124–130. http://dx.doi.org/10.1207/s15430421tip3903_2.

Croucher, S. (2016). *Understanding communication theory: A beginner's guide*. New York, NY: Routledge.

Curtis, M. (2016). "Sister Mothers": Turkish American Muslim mothers' and grandmothers' networks in diaspora. In M. A. Pappano & D. M. Owan (Eds.), *Muslim mothering: Global histories, theories, and practices*. Toronto, ON: Demeter Press.

Denzin, N. K. (1989). *Interpretive interactionism*. Newbury Park: Sage Publications.

Denzin, N. K., & Lincoln, Y. S. (Eds.). (1994). *Handbook of qualitative research*. Thousand Oaks, CA: Sage Publications/

Dow, D. M. (2016). Integrated motherhood: Beyond hegemonic ideologies of motherhood. *Journal of Marriage and Family, 78*(1), 180–196.

Drummond, D., & Orbe, M. P. (2009). "Who are you trying to be?": Identity gaps within intraracial encounters. *Qualitative Research Reports in Communication, 10*(1), 81–87. https://doi.org/10.1080/1745943090323609.

Duck, S. (1990). *Human relationships: An introduction to social psychology*. London, UK: Sage Publications.

Dwyer, S. C., & Buckle, J. L. (2009). The space between: On being an insider–outsider in qualitative research. *International Journal of Qualitative Methods, 54*, 63. https://doi.org/10.1177/160940690900800105

Easton, K. L., McComish, J. F., & Greenberg, R. (2000). Avoiding common pitfalls in qualitative data collection and transcription. *Qualitative Health Research, 10*(5), 703–707.

Elegbede, A. M. (2016). Constructing counter-narratives of the "good" Muslim mother in Kuala Lumpur, Malaysia. In M. A. Pappano & D. M. Owan (Eds.), *Muslim mothering: Global histories, theories and practices*. Toronto, ON: Demeter Press.

Fairclough, N. (1992). Discourse and text: Linguistic and intertextual analysis within discourse analysis. *Discourse & Society, 3*(2) 193–217.
Fairclough, N., Mulderrig, J., & Wodak, R. (2011). Critical discourse analysis. In Teun A. van Dijk (Ed.), *Discourse studies: A multidisciplinary introduction*. London, California, Singapore: Sage Publications.
Faulkner, S. L., & Hecht, M. L. (2011). The negotiation of closetable identities: A narrative analysis of lesbian, gay, bisexual, transgendered queer Jewish identity. *Journal of Social and Personal Relationships, 28*(6), 829–847. https://doi.org/10.1177/0265407510391338.
Fox, R. (2016). Mourning mothers in Iran: Narratives and counter-narratives of grievability and martyrdom. In M. A. Pappano & D. M. Owan (Eds.), *Muslim mothering: Global histories, theories, and practices*. Toronto, ON: Demeter Press.
Glaser, B., & Strauss, A. (1967). *The discovery of grounded theory: Strategies for qualitative research*. Mill Valley, CA: Sociology Press.
Goffman, E. (1959). *The presentation of self in everyday life*. Edinburgh, UK: University of Edinburgh Social Sciences Research Center.
Greene, M. J. (2014). On the inside looking in: Methodological insights and challenges in conducting qualitative insider research. *The Qualitative Report, 19*(29), 1–13.
Guba, E. G., & Lincoln, Y. S. (1994). Competing paradigms in qualitative research. In N. K. Denzin & Y. S. Lincoln (Eds.), *Handbook of qualitative research* (pp. 105–117). Thousand Oaks, CA: Sage Publications.
Haddad, Y. (2006). *Muslim women in American: The challenge of Islamic identity today*. New York, NY: Oxford University Press.
Hajer, A. (2021). Ideology and identity: Operating together. *European Journal of English Language and Literature Studies, 9*(7), 39–48.
Hamed, S. (2017). "The Mother Is a School" Muslim mothers and their religio-educative roles. *Journal of the Motherhood Initiative for Research and Community Involvement, 7*(2). Retrieved from https://jarm.journals.yorku.ca/index.php/jarm/article/view/40365
Harding, S. (1987). The method question. *Hypatia, 2*, 19–35. https://doi.org/10.1111/j.1527-2001.1987.tb01339.x
Hecht, M. L. (1993). 2002-a research odyssey: Toward the development of a communication theory of identity. *Communication Monographs, 60*(1), 76–82. https://doi.org/10.1080/0363775930937629.
Hecht, M. L., & Lu, Y. (2014). Communication theory of identity. In T. L. Thompson (Ed.), *Encyclopedia of health communication* (pp. 225–227). Thousand Oaks,CA: Sage Publications.
Hecht, M. L., & Phillips, K. E. (2021). Understanding the multilayered nature of identity. In D.O. Braithwaite and P. Schrodt (Ed.), *Engaging Theories in Interpersonal Communication: Multiple Perspectives* (pp. 221–232). New York, NY: Routledge.
Hecht, M. L., Collier, M. J., & Ribeau, S. (1993). *African American communication: Ethnic identity and cultural interpretation*. Newbury Park, CA: Sage Publications.
Hecht, M. L., Jackson II, R. L., & Ribeau, S. A. (2003). *African American communication: Exploring identity and culture*. Mahwah, NJ: Lawrence Erlbaum Associates.

Hecht, M. L., Warren, J., Jung, E., & Krieger, J. (2005). The communication theory of identity. In W. B. Gudykunst (Ed.), *Theorizing about intercultural communication* (pp. 257–278). Thousand Oaks, CA: Sage Publications.

Hendrix, K. G. (2002). "Did Being Black Introduce Bias Into Your Study?": Attempting to mute the race-related research of Black scholars. *Howard Journal of Communication, 13*(2), 153–171.

hooks, B. (1984). *Feminist theory: From margin to center*. Cambridge, MA: South End Press.

hooks, B. (1990). *Race, gender, and cultural politics*. Cambridge, MA: South End Press.

Howell, K. E. (2013). *An introduction to the philosophy of methodology*. London, UK: Sage Publications.

Isgandarova, N. (2016). The impact of maternity beliefs on reproductive health in Muslim societies. In M. A. Pappano & D. M. Owan (Eds.), *Muslim mothering: Global histories, theories, and practices*. Toronto, ON: Demeter Press.

Jung, E. (2004). Korean Americans' identity gaps in interethnic interaction and levels of depression. Retrieved from https://search.proquest.com/docview/305152796?accountid=26417

Jung, E. (2011). Identity gap: Mediator between communication input and outcome variables. *Communication Quarterly, 59*(3), 315–338.

Jung, E., & Hecht, M. L. (2004). Elaborating the communication theory of identity: Identity gaps and communication outcomes. *Communication Quarterly, 52*(3), 265–283. https://doi.org/10.1080/0146337040937019.

Jung, E., Hecht, M. L., & Wadsworth, B. C. (2007). The role of identity in international students' psychological well-being: A model of depression level, identity gaps, discrimination, and acculturation. *International Journal of Intercultural Relations, 31*, 605–624.

Kawash, S. (2011). New directions in motherhood studies. *Signs, 46*(4), 969–1003.

Khan, S. (1998). Muslim women: Negotiations in the third space. *Signs, 23*(2), 463–494.

Kinser, A. (2010). *Motherhood and feminism*. Berkeley, CA: Seal Press.

Lacassagne, A. (2016). Muslim, immigrant, and francophone in Ontario: A triple minoritization or how to see mothering as an integrative process. In M. A. Pappano & D. M. Owan (Eds.), *Muslim mothering: Global histories, theories, and practices*. Toronto, ON: Demeter Press.

Lincoln, Y. S., & Guba, E. G. (1985). *Naturalistic inquiry* (Vol. 75). Sage Publications. https://doi.org/10.1016/0147-1767(85)90062-8.

Lingin-Ali, U. (2016). Managing the family, combatting violence: Faith as resource and promise of the good life in case studies of migrant Muslim mothers in Germany. In M. A. Pappano & D. M. Owan (Eds.), *Muslim mothering: Global histories, theories, and practices*. Toronto, ON: Demeter Press.

Lipka, M., & Hackett, C. (2017). *Why Muslims are the world's fastest-growing religious group*. Pew Research Center. Retrieved from: https://www.pewresearch.org/short-reads/2017/04/06/why-muslims-are-the-worlds-fastest-growing-religious-group/

Littlejohn, S. W. (1983). *Theories of human communication* (2nd ed.). Belmont, CA: Wadsworth Publishing Co.

Merton, R. K. (1972). Insiders and outsiders: A chapter in the sociology of knowledge. *American Journal of Sociology, 78*(1), 9–47.

Nurmila, N. (2016). Social and religious constructions of motherhood in Indonesia: Negotiating expectations of childbearing, family size, and governmental policies. In M. A. Pappano & D. M. Owan (Eds.), *Muslim mothering: Global histories, theories, and practices*. Toronto, ON: Demeter Press.

O'Reilly, A. (2006). *Rocking the cradle: Thoughts on motherhood, feminism, and the possibility of empowered mother*. Toronto, ON: Demeter Press.

O'Reilly, A. (2010). *Encyclopedia of motherhood*. Thousand Oaks, CA: Sage Publications.

O'Reilly, A., & Porter, M. (2006). Introduction. In M. Porter, P. Short, & A. O'Reilly (Eds.), *Motherhood: Power and oppression*. Toronto, ON: Women's Press.

Oh, I. (2010). Motherhood in Christianity and Islam: Critiques, realities, and possibilities. *The Journal of Religious Ethics, 38*(4), 638–653.

Oh, I. (2016). Theoretical constructions of Muslim motherhood. In M. A. Pappano & D. M. Owan (Eds.), *Muslim mothering: Global histories, theories, and practices*. Toronto, ON: Demeter Press.

Paget, M. A. (1983). Experience and knowledge. *Human Studies, 6*(1), 67–90.

Pappano, M. (2016). Muslim adoptive mothering in a transnational context. In M. A. Pappano & D. M. Owan (Eds.), *Muslim mothering: Global histories, theories, and practices*. Toronto: Demeter Press.

Pappano, M., & Olwan, D. M. (2016). Muslim mothering: Between sacred texts and contemporary practices. In M. A. Pappano & D. M. Owan (Eds.), *Muslim mothering: Global histories, theories, and practices*. Toronto, ON: Demeter Press.

Patton, M. Q. (2002). *Qualitative research and evaluation methods* (3rd ed.). Thousand Oaks, CA: Sage Publications.

Petronio, S. (1991). Communication boundary management: A theoretical model of managing disclosure of private information between marital couples. *Communication theory, 1*(4), 311–335.

Phillippi, J., & Lauderdale, J. (2017). A guide to field notes for qualitative research: Context and conversation. *Qual Health Res, 28*(3), 381–388.

Rich, A. (1986). *Of woman born: Motherhood as an experience and institution*. London: Norton and Company LTD.

Robertson, M. H. B., & Boyle, J. S. (1984). Ethnography: Contributions to nursing research. *Journal of Advanced Nursing, 9*, 43–49.

Rouse, C. M. (2004). *Engaged surrender*. Berkely, CA: University of California Press.

Rubin, H. J., & Rubin, I. S. (2012). *Qualitative interviewing: The art of hearing data* (3rd ed.). Thousand Oaks: Sage Publications.

Ruddick, N. (1995). *Maternal thinking: Toward a politics of peace*. Boston: Beacon.

Said, E. W. (1978). *Orientalism*. New York, NY: Pantheon Books.

Saidin, K., & Yaacob, A. (2017). Insider researchers: Challenges and opportunities. *Proceedings of the ICECRS, 1*(1), 849–854. ISSN 2548-6160.

Schielke, S. (2010). Second thoughts about the anthropology of Islam, or how to make sense of grand schemes in everyday life. Working Papers, 2. Zentrum Moderner Orient.

Schleifer, A. (1986). *Motherhood in Islam*. Louisville, KY: The Islamic Texts Society.

Shaheen, J. G. (2009). *Reel bad Arabs: How Hollywood vilifies a people*. Brooklyn, NY: Olive Branch Press.

Shirazi, M. (2016). A poetic inquiry: Muslim mothering and Islamophobia. In M. A. Pappano & D. M. Owan (Eds.), *Muslim mothering: Global histories, theories, and practices*. Toronto, ON: Demeter Press.

Simons, H. (2009). *Case study research in practice*. London: Sage Publications.

Sinno, N. (2016). Empowered Muslim mother: Navigating war, border crossing, and activism in El-Haddad's Gaza Mom. In M. A. Pappano & D. M. Owan (Eds.), *Muslim mothering: Global histories, theories, and practices*. Toronto, ON: Demeter Press.

Sohofi, S. M. (n.d.). *The status of mothers in Islam*. Al-Islam.org. Retrieved on May 12, 2021 from www.al-islam.org/status-mothers-islam-sayid-muhammad-sohofi

Stake, R. E. (1995). *The art of case study research*. Thousand Oaks, CA: Sage Publications.

Stake, R. E. (2005). Qualitative case studies. In N. K. Denzin & Y. S. Lincoln (Eds.), *The SAGE handbook of qualitative research* (3rd ed.). Thousand Oaks, CA: Sage Publications.

Strauss, A., & Corbin, J. M. (1990). *Basics of qualitative research: Grounded theory procedures and techniques*. Newbury Park, CA: Sage Publications.

Tajfel, H., & Turner, J. C. (2004). The social identity theory of intergroup behavior. In J.T. Jost and Sidanius (Eds.), *Political psychology* (pp. 276–293). Washington, DC: Psychology Press.

Takseva, T. (2018). Motherhood studies and feminist theory: Elisions and intersections. *Journal of Motherhood Initiative for Research and Community Studies*, 9(1), 177–194.

Thomas, G. (2016). *How to do your case study*. London: Sage Publications.

Thurer, S. (1995). *The myths of motherhood: How culture reinvents the good mother*. Boston, MA Houghton Mifflin.

U.S. Bureau of Labor Statistics. (2015). *Current Population Survey, Annual Social and Economic Supplement*. Retrieved on April 13, 2021. http://www.bls.gov/ncs/ebs/benefits/2015/ownership/civilian/table40a.htm.

U.S. Census Bureau. (2020). *National demographic analysis*. Retrieved https://www.census.gov/data/tables/2020/demo/popest/2020-demographic-analysis-tables.html

Upal, H. M. (2005). A celebration of mothering in the Qur'an. *Journal of the Motherhood Initiative for Research and Community Involvement*, 7(1). Retrieved from https://jarm.journals.yorku.ca/index.php/jarm/article/view/4957

Van Dijk, T. A. (1993). Principles of critical discourse analysis. *Discourse and Society*, 4, 249–283.

Van Dijk, T. A. (1995). Discourse analysis as ideology analysis. In C. Schaffner & A. Wenden (Eds.), *Language and peace* (pp. 17–33). Aldershot: Dartmouth Publishing.

Van Dijk, T. A. (1998). *Ideology: A multidisciplinary approach*. London, UK: Sage Publications.

Van Dijk, T. A. (2009). *Discourse and context: A sociocognitive approach*. Cambridge, UK: Cambridge University Press.

Van Dijk, T. A. (2011). Introduction: The study of discourse. In Teun A. van Dijk (Ed.), *Discourse studies: A multidisciplinary introduction*. London, CA and Singapore: Sage Publications.

Vandenberg-Daves, J. (2014). *Modern motherhood: An American history*. New Brunswick, NJ and London, UK: Rutgers University Press.

Wadud, A. (2006). *Inside the gender jihad: Women's reform in Islam.* Oxford, UK: Oneworld Publications.

West, R., & Turner, L. H. (2009). *Understanding interpersonal communication: Making choices in changing times.* Boston, MA: Wadsworth/Cengage.

Wood, A. W. (1988). Ideology, false consciousness, and social illusion. In B. P. McLaughlin & A. O. Rorty (Eds.), *Perspectives on self-deception* (pp. 345–363). Berkeley,CA: University of California Press.

Zhang, Y., & Wildemuth, B. M. (2009). Qualitative analysis of content. In B. M. Wildemuth (Ed.), *Applications of social research methods to questions in. Information and Library Science.* Westport, CT: Libraries Unlimited.

INDEX

B

Barlas, Asma 22, 24
breastfeeding 25, 29, 51, 58

C

case study 35, 38
children, rights of 58, 83 (*see* breastfeeding)
Collins, Patricia Hill 18–20
Communication Theory of identity 7, 13–14, 35, 38–39, 95
 communal identity 39–40, 49, 68, 73–77, 79–82, 95
 enacted identity 39–41, 56–57, 68, 74, 77–79, 83
 identity gaps 77–79
 personal identity 39–40, 74, 89
 relational identity 20, 39–41, 56–57, 63, 68, 74, 77–78, 83, 95

F

fathers
 in Islamic scripture 50–51
 roles 62– 68, 83

H

hadith 4–5, 9–10, 20, 22–23, 25, 32–33, 53, 58, 65–66, 87
Hajar, story of 21
hooks, bell 18

I

Identity (*see* Communication Theory of Identity)
Ideology 2, 10, 12, 40–42, 81
 and identity 82–83
 illusion of 85–86

protecting ideology 83–85
insider research 14, 36, 42, 85, 87–90, 93
Islam
 as culture 10
 definitions of 9–11

M

Motherhood
 as an empowered identity 27–30
 as an ideology 2–3, 13, 21–22, 49–52
 as disempowering 31
 as performance 4, 68–72, 77–80
 biological and non-biological 20–21
 myth of motherhood 2
 non-white motherhood 18–20
 social institution of 2–3, 18–19, 21
Motherhood Studies 12, 17–18, 87
mothering, definition of 18
mothers (*see* Motherhood)
Muslims, demographics in America 11
 (*see also* Islam)

P

patriarchy 12–13, 21–22, 24, 26–27, 29, 32–33, 87

Q

qualitative research 6, 36–37, 46,

Qur'an 5, 9, 20, 22, 25, 29, 52–53, 56, 76, 87

R

Rich, Adrienne 2–3, 17–18, 24, 26
Ruddick, Sandra 3, 17–18, 86

S

Schleifer, Aliah 22–25

U

Unstructured interviewing 14, 45–46, 88, 94,

V

Van Dijk, Teun 41–42, 81–86

W

Wadud, Amina 3, 5, 18, 20–22, 24–27, 85, 95–96
white feminism 18–19

Studies in Communication, Culture, Race, and Religion

Andre E. Johnson, *Series Editor*

Studies in Communication, Culture, Race, and Religion examines how communication and cultural frameworks help shape our understanding of race and religion—and in turn, how foregrounding race and religion shapes our understanding of how we communicate and interpret culture. Grounded in communication methodology and theory, books in this series also contribute to our understanding of how communication helps shape culture and how culture shapes how we communicate. Using both historical and contemporary perspectives, studies in this series demonstrate how media and culture are intertwined with race and religion.

Since these subjects are interdisciplinary, this peer-reviewed book series invites proposals for monographs and edited volumes from scholars across all academic disciplines using varied communication methodologies and theories. This series provides space for emerging, junior, and senior scholars engaged in research that studies the intersection of communication, culture, race, and religion to publish exciting and groundbreaking work.

For additional information about this series or for the submission of manuscripts, please contact:

editorial@peterlang.com

To order books, please contact our Customer Service Department:

peterlang@presswarehouse.com (within the U.S.)
orders@peterlang.com (outside the U.S.)

Or browse online by series at www.peterlang.com

www.ingramcontent.com/pod-product-compliance
Lightning Source LLC
Chambersburg PA
CBHW061720300426
44115CB00014B/2763